BITTERSWEET
journey

Ruth Hegarty won the 1998 David Unaipon Award for unpublished Aboriginal and Torres Strait Islander writers with her entry "Is That You, Ruthie?" She has raised a family of eight children and lives in Brisbane, and for more than thirty years has been involved on a volunteer basis in projects for the elderly and youth. A founding member of Koobara Aboriginal & Torres Strait Islander Family Resource Centre, she is president of the Brisbane respite centre Nalingu, and a trainer with the Home and Community Care Resource Unit. In 1998 she was awarded the Premier's Award for Queensland Seniors, for outstanding service to the community.

RUTH HEGARTY
BITTERSWEET
journey

UQP

First published 2003 by University of Queensland Press
Box 6042, St Lucia, Queensland 4067 Australia
Reprinted 2007, 2012, 2015, 2018, 2020, 2021
www.uqp.com.au

Typeset by University of Queensland Press
Printed in Australia by McPherson's Printing Group

This project has been assisted by
the Commonwealth Government through
the Australia Council, its arts funding
and advisory body.

Sponsored by the Queensland Office
of Arts and Cultural Development.

Cataloguing in Publication Data
National Library of Australia

Hegarty, Ruth, 1929- .
 Bittersweet journey.

 1. Hegarty, Ruth, 1929- . 2. Aborigines, Australian –
 Women – Biography. 3. Aboriginal Australians – Treatment.
 4. Aborigines, Australian – Government policy. 5.
 Cherbourg Aboriginal Settlement (Qld.) I. Title.

362.732

ISBN 978 0 7022 3414 9

*I dedicate this book to
Cherbourg Aboriginal Settlement.*

Contents

Foreword

Since the 1970s and 1980s, when Aboriginal Australians began sharing their life experiences and histories, we late-comers to this ancient land have been given an opportunity to gain new and better understandings of our shared but complex past. Where once non-Indigenous Australians could, legitimately, pose the question: "Why weren't we told?" the generous sharing of personal stories, in particular, has left us with no excuse for continued ignorance.

Ruth Hegarty, winner of the 1998 David Unaipon Award for her memoir of life as a Cherbourg "dormitory girl", is a storyteller extraordinaire! Yet, Auntie Ruth is a person who is constantly surprised and humbled by her success as a writer. She finds it difficult to accept that her first effort, *Is That You, Ruthie?* has not only been acclaimed nationally but now appears on "required reading" lists for primary, secondary and tertiary students. It is

ironic indeed that the dormitory girl who was denied any opportunity to proceed with schooling beyond Grade Four is now welcomed and feted at schools, universities and the most prestigious of gatherings.

When *Ruthie* was published and launched in 1999, I well remember the trepidation with which Auntie Ruth awaited comments from her family and friends for, in this book, she divulged much that hitherto had been kept close to her heart. She was justly rewarded as her readers accompanied her on a journey marked by both tears and laughter, came away enriched and ... asked for MORE!

On reflection I can't quite bring to mind how it was that *I* became the person who would record from Auntie Ruth's neat, handwritten sheets this sequel to *Is That You, Ruthie?* I do know, however, that whilst we wrestled with re-writing and re-typing whole chapters, changing numerous words and phrases for something "better" and generally going through all the pangs of self-revelatory authorship, I was being *honoured* in a most extraordinary way.

In sharing this journey with Auntie Ruth I have come to know and respect a remarkably strong and Christian woman who often threatens to "take a break" but doesn't know the meaning of leisure or self-indulgence. Through her wisdom I have come to understand that the past is never *past* and will always influence the present and the future. Through her generosity of spirit and comradeship

I have been welcomed into the Murri community and am enriched by many new friendships.

However, as a voracious reader whose working life has long been linked to books and writing, I am especially proud to have been given the opportunity to be part of the process that brings to you, the reader, this eagerly awaited new work. The question most commonly asked of Auntie Ruth as she talks to groups, organisations and students about her life as a dormitory girl is: "What happened to Ruthie and Joe after the wedding?" What is revealed in *Bittersweet Journey* is that Joe not only *wanted* the story recorded but also gave his approval for its telling as a very special gift to Ruthie who endured so much pain and suffering throughout their life together.

With this new book Ruth Hegarty, author, has recorded living history that will give readers a very honest insight into her life experiences as she, Joe and family contend with and triumph over harsh government policy and a move from the confines of Cherbourg to the "big smoke" of Brisbane. At the same time, Auntie Ruth, respected Elder and tireless worker for her people, has written from her heart with courage, warmth and humour a story that will inspire and encourage us all — Indigenous and non-Indigenous Australians — to continue the journey towards a just and respectful conciliation.

Congratulations Auntie Ruth — I am confident that *Bittersweet Journey* will more than fulfil your readers'

expectations but be prepared to hear them say yet again: "What happens next?" I'm ready when you are!

Bev Hickey
Reconciliation Queensland Inc.
Committee member

Noonga Reconciliation Group Inc.
Secretary

Acknowledgments

I thank my five daughters, Cassandra, Glenys, Pheonia, Mayleah and Moira, and my three sons, Norman, Duncan and Emmanuel, for their expression of general agreement when I announced I would continue my writing and that it would contain many accounts of our shared life. Without being fully aware of its contents they supported my efforts. I thank my brother-in-law, Peter Hegarty, who on reading the draft copy of *Bittersweet* fully approved its publication. I thank my good friend, Bev Hickey, for her patience and perseverance as she typed and re-typed pages and pages of hand-written material and often endured the changing of words and phrases of a writer who was on a quest for perfection. I acknowledge that my life lived in Cherbourg gave me the historical background that enabled me to document a journey that is now a "living" history. I acknowledge the people of Cherbourg, past

and present, particularly my beloved in-laws Mr and Mrs Hegarty and family. This book is not meant as a means to desecrate or to dishonour their memory. I was proud to belong to a family who strived to give their children a more pragmatic and effective life in spite of the poverty and despair that surrounded them. My thanks to Sue Abbey from UQP for her support and encouragement and also to the best editor I know — Margaret McDonell.

I also acknowledge and thank Thom Blake and Ros Kidd for background information on the stolen wages case, from Thom's book *A Dumping Ground: A History of the Cherbourg Settlement* (UQP 2001), and from a talk, "The Struggle for Justice", delivered by Ros to the Forum on Stolen Wages and Financial Discrimination against Indigenous Australians (University of Queensland, 1 March 2001).

Chapter 1
The Journey Begins

On the morning of 15 December 1951 the women in our Dormitory allowed me to remain in bed a little longer than the rules permitted. This was my special day so they granted me the luxury of sleeping in. Saturday mornings at the Dormitory weren't any different from weekdays as far as rules were concerned. Just because it was the weekend the rules were not relaxed. No one could remain in bed, we rose at the same time each day in the same regimented fashion that was set in place when the Mission was established.

I'd been captive to life in the Dormitory since I was six months old, living under its rules and system of bells that told you when to get up and when to go to meals. You learned that freedom from the Dormitory system was almost impossible, that getting married might be the only option to legitimately take you away from this oppressive life.

The bell would ring, however today I would disregard it. This was the day of my marriage to Joe Hegarty Jnr. It was also the day that would end my twenty-two years as an inmate of the Cherbourg Aboriginal Mission.

I appreciated the time alone. I shared the long verandah sleepout with about fifteen other single mums and children. The sleepout was an overcrowded section of the Babies Dormitory, single iron beds in rows were placed along both sides of the verandah with barely sufficient room to allow a pathway from one doorway to the other. The space I occupied was just large enough for the single bed and a single combination wardrobe. At this time of the morning it was usually very noisy, however right now it was really quiet and it allowed me a chance to reflect.

It was strange but, somehow, I wasn't feeling too anxious about leaving. These Dormitories had, over the years, given me a home and, as much as I loved Joe and wanted today's marriage to take place, I knew that I was going to miss these familiar surroundings. I guess it happens to anyone leaving home, especially to get married. I'd thought about the many times I went out to work as a domestic but this was different; going to work meant I was coming back, because our employment contracts were for six or twelve months.

This time there was a feeling of finality. I'd never resented Dormitory life, it had given me a wonderful family. It was the rules more than anything that I resented. I

wanted to feel free and I thought the people from the Camp possessed that freedom, and going there would give it to me. I saw myself going places without needing a police escort or a permit, perhaps visiting the homes of other women who once lived in the Dormitory. I lay there overcome with a mixed-up feeling of wanting to go and yet wanting to remain.

I sat up in bed and focused on my dress hanging on the wardrobe door. I made it myself and was rather pleased with the outcome. I couldn't afford a wedding dress and I had never attempted to make anything that required the use of needle and cotton. But I was determined to sew my wedding dress, not because I was good at dressmaking but because I had so little money. I had no talent when it came to sewing, knitting, crocheting, and I'll add cooking to that list. My friends asked, "Are you sure you want to do that?" They reminded me that I was not skilled in dressmaking and that I'd ruin everything. I wouldn't listen, I went ahead just to show them I could.

Three yards of pretty blue sateen material dotted with tiny pink flowers was all I could afford; it cost me a fortnight's wages. The pattern I used was cut from an old dress that I was fond of wearing. I carefully unpicked the stitching, taking good care not to make any unnecessary rips in the fabric. The girlfriends offered lots of advice, even gave a hand in unpicking the dress. With my blue sateen laid out carefully on the Dormitory's long dining

table I began the very delicate task of cutting out my wedding dress, under the watchful eyes of onlookers who were certain that I could not do it. I held my breath as the scissors cut through the material. Every stitch was hand-sewn — in between going to work, tending to the baby's needs, waiting to take my turn in the laundry and then at the clothes line.

Auntie Mabel said it looked a bit plain and offered me a quarter yard of blue lace to make into a peplum to tie around the waist. I successfully sewed that together and thought how nice it looked. Auntie Mabel was a very generous, giving person, one of those fine, gracious ladies who always dressed as though going to meet the Queen.

It's every girl's dream to look and feel good on her wedding day and I desperately wanted that. I would have liked to have gone into Murgon, four miles away, to have my hair done. Unfortunately I didn't possess a head of beautiful curls like the rest of the girls. My hair was dead straight, fine and mousy. However there were certain rules in place that would have prevented me from going to the hairdresser. First there was the standard procedure of obtaining a permit to go into Murgon, and then the obvious question of whether I, as an Aboriginal, would be allowed into a hair salon.

I did the only thing I could do. My hair was rolled up the night before using electrical wire, and black tea with sugar as a setting lotion. I was anxious to take the wires off

my head; I had endured a night of great disturbance as every time I moved my head it felt like I was sleeping on rocks.

I'd known Joe Hegarty Jnr all my life. We attended the same Mission School and the same Sunday School at the Aboriginal Inland Mission (AIM) Church. Our names were linked together all those years, even marriage to each other was talked about for when we grew up. His mother reminded us some weeks after our wedding that we were destined to marry. Joe Jnr was born on the morning that my mother Ruby and I, along with our family, arrived in Barambah (as Cherbourg was then called) from Mitchell. I was six months old and Mrs Hegarty recalled that I was placed on a hospital bed while my mother was having a medical check before we were placed in the Dormitory. I was asleep so it seemed all right to leave me lying on the bed. However I awoke, rolled over and, of course, landed on the floor. There was a rush to pick me up but nowhere to lay me, so when I finally fell asleep Mrs Hegarty suggested I lie in the cot with her new baby son Joseph.

Joe and I were delighted to hear that story. Our attraction to each other was evident right through school, and years later a deep friendship developed. After leaving school and going to work our lives went in different directions. I last saw Joe when I was sent out to work at fourteen years of age. He was among the crowd that waited with me, until the taxi arrived, to say goodbye. I remem-

ber clearly that as he said goodbye he kissed me — a quick peck and he was off. He was thirteen. As the taxi sped along I spotted him running down the first bridge on his way home. We would, in the next nine years, see very little of each other. However he came back, and he was not the boy I knew at school. He was a man, still very handsome, unattached and looking good.

The girl he once knew was now the mother of two girls and was still living in the Dormitory. My eldest, Cassandra, was three years old and was fostered out to my good friends Barron and Winnie Douglas who lived at the Camp — I was adamant that she would not be a Dormitory girl. Glenys and I were alone, and I had given up the idea of ever leaving the Dormitory. Our lives would follow the same route that began with my mother's internment and mine. Glenys would get caught up in the same regimented life. I was able to get Cassandra out of it, but for us there was no way out. It was easy to fall into the pattern of rules and regulations. To avoid any trouble one obeyed rather than suffer the consequences.

When you can't change anything, you live with what you've got and make the most of it. Glenys was three months old when I began work at the Mission Hospital, five days a week I scrubbed the floors on two large verandahs, starting work at 7.00 a.m. I was paid thirty shillings once a fortnight. With this money I could independently pay my way into movies and an occasional

dance, and purchase a few personal items for myself and the baby.

Each afternoon from 5.00 p.m. to 8.00 p.m. we were allowed free time outside the gates. All scrubbed up and looking good we waited inside the gate until we were given the signal to proceed outside. This gave mothers the opportunity to allow their children to run, play and simply enjoy some free time without restrictions. The three Dormitories opened their gates for these activities, the whole front area was busy with people socialising as well as kids playing games. During those hours many people from the Camp — relations, friends and boyfriends — would visit and it was the only time that young people could meet and court. We were restricted to certain boundaries and we were under the watchful eyes of the Mission police and others in authority. I enjoyed those times, they gave me an opportunity to see my other daughter as Winnie would bring Cassie down to visit.

It was on one of those afternoons that I saw a handsome man making a direct line towards me. I did not recognise him.

"Hello," he said. "It's me, Joe."

Of course it was!

"Hello, Joe Hegarty." It was as though we had never been away from each other. We embraced and he planted a warm, friendly kiss on my lips. For the next few hours we talked and watched Glenys at play. It ended too soon,

the bell rang for us to re-enter the yard. He asked if it was all right if he came back the next afternoon and the next — for eight months until the night he asked me to marry him. I was ready to take the plunge and place myself and my baby into his care. The baby loved him, we both looked forward to his visits. As they say, love was in the air. I was sure he was the right person for me. I insisted we talk about past issues that we had both encountered before I would respond to his proposal. It was agreed the past would remain the past, and I said "yes".

I saw tenderness in him during those months that could not have been faked. I needed somebody I could trust. I was about to move away from the only home I ever knew, and I would be moving to what was to me at that time unfamiliar surroundings. I was going to live at the Camp, an area of the Mission that was occupied by families who had, over past years, been forcibly removed from their lands by Governments. Members of several clans were settled on the Mission, each clan established their own campsite. Many years on, the whole of that area became known as the Camp. I was entrusting myself to the care of my husband who would introduce me to Camp life.

If Joe thought asking me to marry him was tough, the next step was tougher. I was still a Ward of the State and a Dormitory girl, so he had to seek approval of those in power. In 1951 those of us who lived under the Dormi-

tory system had to first get the Superintendent's permission to marry. Rules are rules and wanting to marry was no exception. Our excitement had to pass the test of endorsement from both the Matron and the Superintendent. These were the "joy stealers" who had the capacity to dampen our high spirits.

On Saturday morning I went from the Babies Dormitory to the Matron's office at the Big Dormitory. I needed to get their permission to go to the main office as Joe and I had agreed to meet there. It was the most opportune time for us to see the Superintendent (or Boss, as he was commonly known). My meeting with Matron was swift as she approved my visit to the office and arranged an escort — a policeman, of course. She needed to know why I wanted to see the Boss.

She looked surprised when I informed her that I was going to marry Joe Hegarty Jnr. She had no interest in my private life. I waited, hoping she would congratulate me. Somehow I didn't think she would — and I was right! I was just another statistic to her, my baby and I would be just two people less to feed. My roots were here, everything I was had developed out of this life. I knew no other.

I was to learn, however, that Joe and I were two people who were very different and over the years those differences would cause as much pain and disharmony. We would marry without knowing how different our lives would be. Even though we were sure we knew each other,

our lives lived as Dormitory girl and Camp boy would have a disastrous effect. I lived my life under a system whose history was notorious for the deprivation of the liberty of its inmates. I had not ever experienced a normal family life, the bonding, the socialisation, things that are the accepted norm. In a report quoted in the Cape York Justice Studies, tuberculosis specialist Dr F. M. Macklin said, "The dormitory system is a thoroughly pernicious one, which must be broken down if these coloured women are to be properly adjusted to a normal life." A "normal" life as we knew it was lived behind barbed wire, under constant supervision, with no freedom. A visit to the Camp was allowed only if the family you were visiting was at the Dormitory gate to pick you up and they'd be required to walk you back to the Dormitory afterwards. These visits could happen on Saturdays between noon and 5.00 p.m., and not every Saturday. Joe and I had spent very little free time together. I knew nothing about his life or his friends, and I wouldn't have a clue until we were married.

Joe was waiting for me at the Superintendent's office and I was anxious not to be late. The escort police arrived — it was my own Uncle Eric, one of my mother's younger brothers and my favourite uncle. It wasn't a long walk, the office was on the same street as the Girls Dormitory, up the road past the Babies Dormitory and the Boys Home. As we walked around to the private entrance to the Super-

intendent's office my nervousness was suddenly put to rest as I spied Joe leaning against the fence. He looked as he always did, so handsome with a smile to match. He was all I'd hoped for. I was marrying into a very respected family and I wanted them to accept me. I was ushered onto the small porch where Joe joined me before we went in to make our request of the Superintendent. Looking back over the years I realise just how much power those people had over us. From the moment we entered his office we didn't relax, we would've loved to have held hands. I knew the power they possessed, I was still a Ward of the State and that would not change, not even after I married. However, we felt so much joy nothing could diminish it. With Joe at my side, I stood before this man who represented the power that controlled my life, even to the point of approving my marriage.

Looking directly at Joe he asked, "So you want to get married?"

"Yes."

"Do you have your father's consent?"

"I don't need it," Joe replied, "I'm over twenty-one." I realised then that we hadn't officially been given the blessings of both Mr and Mrs Hegarty.

I was not asked anything. However, the Superintendent produced the papers we needed to sign and informed us both that a letter of consent would be sent to the Brisbane office of the Department of Native Affairs. We could do

nothing until these forms were returned to the Cherbourg office from the main Brisbane office where the Aboriginal Protector, Pat Killoran, would have to approve them.

Later, we laughed about Joe getting his father's consent since at Cherbourg every marriage for generations had to be sanctioned by the Superintendent and not by the biological parent.

In 1951, without modern technology, the wait for an answer from Brisbane could be anything up to six weeks. We were conditioned to the way things were done and were prepared for a six-week wait. The thought that something could go wrong was always in Joe's mind. Our plans for the wedding were placed on hold until we saw the piece of paper that gave us the formal permission we needed. Joe's concern now was that, since I didn't always obey the rules, any punishment could result in our not getting married.

"Ruthie," he said, "don't get people offside while we're waiting."

I don't always get people offside. As a long-time inmate of the Dormitories I knew that bending of the rules frequently occurred. If discovered this could result in some form of punishment, for example, a night in jail, or denial of permission to go to the pictures or dances. A list presented to Matron for approval for such an outing might come back minus a couple of names. Joe obviously knew me and I was on my best behaviour.

APPLICATION FOR PERMISSION TO MARRY
(By any two parties one of whom is an aboriginal)

	Male	Female
Name Christian and Surname.		
Identification No. (if any)		
Date of birth		
Breed of parents		
Father		
Mother		
Previous marriage (if any)		
To whom married		
Date and Place		
Legally or Tribally		
If legally married is husband or wife		
still living?		
Number and ages of children		
Provision for future custody of children		
Illegitimate children (if any) Number		
and ages		
Particulars of		
Present custody		
Future custody		
Have parents given consent to marriage		
(required if under 21 years)?		
If not, why?		
House or other accommodation available		
for couple after marriage		
Nature of present employment		
Particulars of wages or income		
Balance of Savings Bank Account		
Signature of applicants		
Witness		

REPORT OF PROTECTOR OR SUPERINTENDENT
Are the above particulars accurate to the best of your
 belief?..............
Are the applicants of good character?.................
Are they free from disease?..........................
Has either party at any time been treated for venereal
 disease or tuberculosis?...................
Is male applicant capable of maintaining a wife?.......
Do you recommend the granting of permission
 to marry?............

I did, however, get the Manager of the Babies Dormitory offside. Less than two weeks to go, and I was in the midst of a very heated argument. I was late for breakfast that morning. In the rush to get to the kitchen I'd thrown on a shirt over my skirt, and tied the shirt-tails up around my middle with my midriff showing.

The next thing I heard was: "You're late!"

"I'm sorry."

"That's not a very decent way to dress."

"I was in a rush."

"You can turn around, go back and get dressed properly."

"No, I won't!" I was adamant that no one was going to tell me how to dress.

The Manager replied, "You won't get breakfast until you look decent."

I refused, he then slapped me, and as I got up I saw Viola tip the pot of porridge over his head. Guess what? I was marched off to jail and told: "That's where you'll spend the next week." Viola brought my meals each day and I was allowed to have the baby sit with me on the small verandah of the jail. I was shut in each night, while Viola took care of Glenys as well as her own Selena.

"Joe's in a panic," she said. Poor man, he thought this wedding would never go ahead!

"Do the right thing," he'd said. Joe was horrified and he told me so when I got out.

"It wasn't my fault," I said, while Viola had a good laugh. Joe didn't think it was funny!

I'd been employed at the Hospital for many months. I'd been six months pregnant when I'd left my previous job as a domestic at Clifton. At the Hospital there were large verandahs, and cleaning the floors required lots of elbow grease. The Matron insisted you use the cloth to first wet the floor in small lots, then use soap and a brush to scrub, then rinse and dry — if it wasn't done in that order she'd tip the whole bucket of water over your finished work and demand you start again. I needed that job so much that I grew eyes in the back of my head and another set of ears to survive. Every penny I earned went towards the wedding.

Shortly before our wedding day my other good friend Nell Cobbo was to wed Jack O'Chin. Joe and I were to stand up for them, we thought it would be good practice for our own wedding. On the morning of the wedding Nell got word that Joe would not be available. He wasn't sick so what was the matter, I wondered. The messenger told us, "Joe said that if he and Ruth are the best man and bridesmaid, they won't marry." There was a real scramble to find a best man at short notice. I was to discover over the years just how superstitious Joe was!

Our consent to marry had come back from head office in Brisbane after six weeks, and it was then full speed ahead to get everything ready with the money I had saved up at the Hospital — in fact I worked on until the day

before our wedding. Joe was employed as a timber cutter, a job he would go back to much later. He was paid five pounds a week and, after paying Mrs Hegarty a small amount (he was living with his parents), he began saving for the cost of a wedding ring.

Form No. 44

"THE ABORIGINALS PRESERVATION AND PROTECTION ACT OF 1939"

PERMIT FOR THE CELEBRATION OF MARRIAGE BETWEEN ABORIGINALS.

I, **Percy John Richards**
Deputy Director of Native Affairs
(x Strike out ~~Protector of Aboriginals~~ for the ~~district~~ **State** of ___**Queensland**___
what is not ~~Superintendent of the Settl~~ement or Mission Reserve
applicable.) _____), hereby give permission by
virtue of Section 19 of the abovementioned Act, for the
celebration of the marriage of the male **Joe Hegarty**
to the female **Ruth Duncan** , who resides in the said **State**
~~District No.(with enumeration area number)~~); the said persons being
aboriginals within the meaning of the said Act.

Dated this **Ninth** day of **November**
in the year **1951.** .

 K

Deputy (Director of Native Affairs
x (~~Protector of Aboriginals~~
 (~~Superintendent of Settlement or
 Mission Reserve~~.

Until the day arrived there was much work to do. I was lucky to have three small girls from the Dormitory babysitting Glenys. Monica, Evelyn and Burma constantly fought over their babysitting duties, however I was able to complete The Dress and even take an interest in planning the wedding reception. The three aunts were well ahead of me with all the arrangements. Auntie Maud

Phillips, the Girls Dormitory Manageress, had a natural flair for organising special events like weddings and church anniversaries. She was a great cook, and knowing this I could rest assured everything would go well. It was she who made the bottom tier of the three-tier wedding cake. Auntie Matty Graham was another talented and wonderful person. A Dormitory cook for a good many years, she was also part of the team. She made the second tier of the wedding cake. And then there was my Auntie Jean Duncan, my mother's younger sister, both our lives were spent in the Dormitory. She was two years older than me and an experienced cook, and she made the top tier of the wedding cake. I really don't know what I did to deserve what these wonderful people did for me.

Joe took care of the church arrangements and the Minister, Mr Living, would marry us. The AIM Church was chosen; we both went there as children. Also, Mrs Hegarty was a member of the Church, and I was happy for them to go ahead with the arrangements. This would be the first time in a lot of years since I had entered the Church. Maybe it was due to the fact that going to church was part of the discipline of the Dormitory; it was not a joyous occasion. As a child living in the Dormitory, going to church was a rigorous routine of three times a week for fourteen years. After leaving school I vowed I would not go there again.

The bond formed by the women and girls in the Dor-

Cherbourg.

Murgon

15th November, **1**

BAS/CB
Ref.58,556 Nats.

Mr.R.M.Living,
A.I.M. Missionary,
MURGON.

 Re <u>Ruth Duncan and Joe Hegarty Jnr.</u>

 Statement of Particulars and Permit for the
marriage of the above couple are enclosed.

 Would you please contact this couple and arrange
with them a date for the celebration of their marriage,
following which, the copy of the Marriage Certificate
usually handed to the bride is to be lodged with this
Office. I understand the couple desire to marry before
Christmas.

 <u>Superintendent.</u>

mitories was that of sisterhood. On the morning of the
wedding they insisted I remain in bed a little longer,
they'd take care of Glenys. This was their gift to me. I
knew I'd miss them all; still, I lay there thinking, *I'll be
glad when I leave all this behind; just a few more hours.*

However there was no time left to dream, suddenly
there were calls of "Get up, Ruthie!" My family of all these
women were urging me on as they hurried back from
breakfast.

"Yeah, you're getting married today!" Comments were
coming from everywhere. It was time to get up. When we

were all in the Babies Dorm it was a madhouse and now, as I joined the other mums and children, it was bedlam. I rushed down to the backyard where the toilets (the old-fashioned pit type), shower room and laundry were located. It was already busy with the early birds doing their washing. The cement laundry tubs were filled with washing, the two coppers were filled with water with a wood fire burning away underneath. I knew what it was like to wait your turn to use those facilities and it could take until late afternoon to get a turn. However, I was given first go of the showers — cold, of course. We didn't have the luxury of hot water. Glenys was in good hands as Burma and Monica were keen to bathe and dress her and take her to the Church.

After weeks of waiting our day had finally arrived. Just a couple more hours and my life would be completely changed! Auntie Mabel arrived with my bouquet of wild-flowers. I knew she would be out early with the small Dormitory girls gathering wildflowers for Sunday Church, and I knew some of them would decorate the Bride's Table. Auntie Mabel also supplied me with a tiny white hat, white gloves and matching shoes. She used to be my Sunday School teacher and always took an interest in us. As a Dormitory girl herself she was fully aware of the system. She worked in Murgon and her days off were spent on the Mission in the Girls Dormitory, or giving her time to missionary work. She was dedicated to her belief

in God. I was sure I had her good wishes when I started the long hot walk to the Church.

Our wedding was scheduled for 11.00 a.m., I would have preferred afternoon but Joe was very keen to have the ceremony as early as possible. I was pushing it for time. I dressed carefully, Auntie Mabel's hat, gloves and shoes were an added blessing, as were the bouquets. I wonder as I write of my journey how I could have had so many wonderful people supporting me. I grew up in the Dormitory system with a rebellious attitude, I was always outspoken, too quick to make comments — sometimes harsh — and very competitive. I had to strive to be best at everything I did. I had several run-ins with Authority because I wanted to have my own way. However, even with all those faults, I felt safe in the Dormitory. It didn't matter what happened outside the home, outside the barbed wire fence — this was my safety net and these were my family and I knew to what extent I could go, even to defying the system.

"Uncle Eric is here for you!" one of the girls called out.

My dear uncle, dressed in a dark double-breasted suit, was waiting for me. Of all of my uncles, six of them, he was the one person I could depend upon to visit me at the Dormitory and who had always been concerned about my welfare. He held the position of sergeant in the Mission police force, it was a job with pay and often he would give me the price of a ticket to the pictures or enough to buy something off the fruit cart. When I was a child, he'd give

me sixpence so I could go to the pictures. Today he was giving me away to Joe Hegarty Jnr. As we walked together proudly towards the Church, neither of us knew just what I was walking into. My bridesmaids, Auntie Matty's daughter, Gwenda, and Joe's cousin, Frances (whom we called Pam), joined me. With Uncle Eric by my side we started out for the Church, a walk we estimated would take us at least half an hour.

Groups of people sat or stood along the route, from the Babies Dorm to the Church. I waved to them as they wished me good luck. Many were my workmates, and other folk along the way were there to watch the wedding procession. Many Dormitory brides had taken this route before me and may have, like me, appreciated the support of well-wishers that added to their special day. After years of searching I had finally discovered a way out of the orderly life where everything was run like clockwork, uniformly controlled by a Matron whose authoritative rule extended to the three Dormitories. I was walking away from it all, vowing that neither I nor my girls would ever again be caught up in that system.

Being an extremely hot day in the middle of December, the half mile was beginning to feel like three by the time we arrived at the Church. The hot bitumen road and high heels didn't help. We arrived late enough for Joe to be concerned.

My uncle made one remark as we walked along, "With

everyone out on the road there won't be too many people in the Church."

I said, "I just hope you're right."

We arrived a few minutes late and I appreciated the looks of approval from some of the older women as well as the offer of a small piece of cloth to dab the perspiration off my face. As we entered the Church I saw that every pew was occupied. The Church is large and the walk down the aisle seemed to take forever. It was a hot morning and as Uncle Eric and I got nearer to my intended husband I could see how uncomfortable he was in his double-breasted suit. He'd had the same look when we went to see the Superintendent. Joe was accompanied by our good friend Len Malone and his cousin Jack Bradley. He looked relieved as I walked up the aisle. He later confessed that he thought I'd changed my mind. We went through the vows in the traditional manner — to love, honour and obey, to stay together through sickness and health. With every vow given I believed with all my heart that we would live happily ever after. I was the dreamer, the storyteller, and the girls I spent time with in the Dormitory believed me when I told them "once upon a time" and ended with "and they lived happily ever after". Our courtship had been shrouded in secrecy, like many courtships were, as any outward sign of intimacy at Cherbourg was frowned upon by Authority. Any display of growing affection or visible evidence that something was going on

would not be tolerated. The obvious thing to do was to take cover in the shadows or under darkness — which had the effect of making us feel that any sort of affection we showed was sordid and shabby.

With the ceremony over the whole congregation clapped as Mr Living pronounced us man and wife and said, "You may kiss the bride!" With a quick little peck from Joe and a sigh of disappointment from the pews we went off to sign the Register. As we walked out of the Church vestry my great-aunt Edie Langton moved towards us, unclasped our hands and very quickly placed my arm through Joe's. She moved aside and told us that that was the right way to walk out of the Church. Lots of rice was thrown and pictures taken, then it was off to the Dormitory with our invited guests to share in the Feast.

I was delighted to see that we were sitting down in the large sewing room and not in the Dormitory dining room. The Aunts had done a great job and the small girls of the Dormitory had helped with the decorations and setting the table. The table coverings were single white sheets ironed with a Mrs Potts iron to look like new. The three-tiered wedding cake took pride of place on the large table. Every now and again during the toasts I'd see the small girls peering through the glass windows, so proud of what they had accomplished. It reminded me of myself as a child peering through the glass on Christmas Day with the other Dormitory girls and waiting for dinner to be

served, with nothing to do but watch as plates of good things to eat were placed on the large dinner table. Just forty people sat down to enjoy all this good food and every one was a member of Joe's family.

I didn't have the opportunity to discuss my plans for marriage with Mum. She lived and worked in Brisbane so we very rarely saw each other. To visit me at Cherbourg

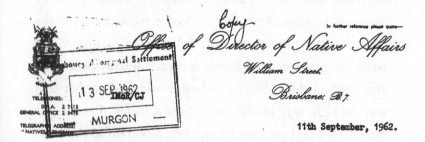

copy

Office of Director of Native Affairs

In further reference please quote—

William Street,

Brisbane, B.7.

11th September, 1962.

TELEPHONES:
D.N.A. 2 7118
GENERAL OFFICE 2 3475

TELEGRAPHIC ADDRESS
" NATIVES " BRISBANE

13 SEP 1962
TMGR/CJ
MURGON

The Superintendent,
Cherbourg Settlement,
via MURGON.

 The Bearer, Ruby Ray has been given permission to visit the Settlement to be with her daughter, Ruth Hegarty, for a period of two weeks.

 She is aware that she must pay maintenance, £1 per week while she is on the Settlement. Ruby will pay all expenses of the visit and no cash should be advanced or orders issued to her.

Director of Native Affairs.

she had to go through the process of obtaining a permit. Through mutual friends I got the message that she was not happy, that she felt I was about to make a mistake. Other members of my mother's family had no objections, although it would have been good to have had their support on the day. I'd gotten used to not having Mum around, I guess as long as I had the support of Auntie Jean, her younger sister, I was happy. Apart from Uncle Eric, our family was rather laid back, sort of easy going. We didn't make demands on each other.

So, except for my Uncle Eric, none of my mother's family turned up. My mother, Ruby, although invited, did not come for the wedding. Because she disapproved of my marriage to Joe, like other times she would show her disapproval by not attending. I was not surprised. The first time it happened I was seventeen years of age and pregnant with Cassie. Mum expressed her disapproval by not visiting me, and then the same with Glenys. I survived that and many years without her. The next time I saw Mother was years later when she brought her intended husband, Len Ray, to meet me, and that was not for my approval.

So much had come between us through the years. My life in the Dormitory began in March 1930 when my grandparents arrived in Barambah (as Cherbourg was then called) from Mitchell to wait out the Depression. Grandfather's sole hope for survival was to take his family

to the only place that was available to them — Barambah
Mission. Immediately we arrived Mum's brothers — Eric,
George, Douglas, Glen and Arthur — were taken from
their parents and placed in the Boys Dormitory. My
mother and I were placed in the Girls Dormitory. She was
the eldest sibling at nineteen. I was just six months old.
She had gone with her parents as she was waiting to marry
Frank, my father, who was away from Mitchell working.
She believed she would return to Mitchell in just a little
while. But there was no "returning", our whole family was
caught up in a system that imprisoned us for all of our
lives. My removal from Mother at the age of four-
and-a-half years slowly severed what had been a close, lov-
ing relationship. In the years following she was constantly
sent out to work, sometimes close by Barambah, other
times far away. Mother was unable to pick up a pen and
write because of illiteracy, so we hardly communicated. I
was fourteen and still in the Dormitory when she ob-
tained her exemption from the Mission. This meant that
she had to get a permit to visit us. The gap widened be-
tween us. I began work, took charge of my own life, and
saw no need to seek her approval since it had never been
there. Joe and I found solace in each other, we considered
that the past was behind us, that maybe a new beginning
was what we both needed. Over time my relationship
with Mum became less tense and more about acceptance
of each other.

No strong drink was allowed at the wedding function. The Dormitory had some very strict rules and here, as well as in the Camp area, there was restriction of alcohol. However, our wedding was not going to be toasted with red cordial because Joe's brother and cousin had sneaked in a bottle of wine. Joe disappeared with his brothers soon after we finished eating and I was left to see the guests off and to help with the cleaning up. At almost 5.00 p.m. he arrived to collect us and take us to our new home.

20 DEC 1951

Cherbourg *Aboriginal Settlement*

via Murgon

17th Decr. 1951

SR/132.8 85/2

All communications should be addressed to the SUPERINTENDENT.

BAS/CB
Ref.556.58 Nats.

Deputy Director of Native Affairs,
BRISBANE.

Re Ruth Duncan and Joe Hegarty Jnr. -Your Ref.
SR/132. 8J/281

The abovenamed were married on the 15th instant according to the rites of the A.I.M.Church.

Superintendent.

Chapter 2
Going Home — to the Camp

Before leaving the Dormitory to begin this new life I took a good look around me. It was natural that I should feel sad but without feeling any regret. For though I was leaving my home and family I was ready to pursue a life with my husband, hopeful that I would make many visits in the future.

I went about preparing our few possessions, placing Glenys in the stroller and, with Joe's words in my ear, "We're going home", we were on our way. I'd only met Joe's parents on a couple of occasions. However my hopes were that they would accept me into their home. The Hegartys were a big family, Bill was the eldest, followed by Iris, Jean and then Joe. Then came his three younger sisters, Merna, Norma and Carmen, and brothers Peace, Peter and Matthew.

The three of us with Jack Bradley walked the half mile

to the Hegartys' home. We laughed and joked as Joe had had a few drinks and it was enough to produce a side of him I hadn't known before. I'd never seen this jovial side or the sight of him under the influence. I laughed along with him and we soon arrived at the house. The room we were to occupy was very small, however that was not a concern. The first two weeks were the happiest. Our baby was embraced by the whole family and it was they who changed her name to Glenys Hegarty. With Joe back at work I began to think about my other home, the Dormitory, and that it was about time I went back for a visit. Viola was to marry Walter Hill on the Saturday and I wanted to catch up with her. Since I was home alone I had not even considered that I would have to seek permission.

I carefully dressed myself, appearances were always high on my agenda. Glenys and I were off on our walk. I hadn't intended to stay such a long time, however there was so much to share. I was surprised at how late it was getting. I remember saying to the girls, "I really have to go or my husband will think I've run out on him." Of course he was waiting. We began waving to him as we came up over the small hill. I was happy to see him as I had so much to share with him. Just as I got close he turned and walked into the house with me hurriedly following behind. I left Glenys with his sisters and on entering our room I was taken by surprise. I encountered a large fist to the side of

my head. Dazed and bleeding I screamed, "What are you doing!"

I was hit repeatedly and then, as suddenly as it started, it stopped. I had the taste of blood in my mouth, I could not see out of my eyes, and my head was pounding. As I touched it there was more blood. Joe was like a crazy person. My mind was trying to make sense of this situation. To be honest I couldn't believe this monster was the man I had married. Suddenly everything was quiet. A quick look around revealed he was not in the room. I picked myself up. I was a mess, I could think of nothing else but getting to safety. I was prepared to go back to the Dormitory, however Joe had returned carrying a bowl of warm water and a clean cloth. As he moved towards me I began trembling like a small animal that had been injured. I had no idea what he would do next, not only was my head pounding I could feel my heart beating as though it would burst.

Joe used such soothing words as he commenced to bathe my bruised and battered face and head. I hated him and at that moment no amount of tenderness and care on his part could erase the grief and pain I was experiencing. For many days I would not have a conversation with him. I cut myself off from the family, because I was ashamed to be seen in that condition by anyone. Although I wanted to know what I had done to deserve this belting I had not spoken to him. His willingness to do anything for me over

the next few days obviously was Joe's way of saying he was sorry. I wanted to go home to the Dormitory, but I was afraid that that would be admitting failure, afraid that if I walked away from this marriage I would be blamed. I wasn't even sure I would be allowed back. It was a sense of fear that drove me to remain where I was. I wasn't sure if or when this would happen again. I sat alone wondering what I should do. I would set some boundaries, no more walks alone. Joe had indicated that he owned me and that I could go out if he said so and, I guess, if he approved. I realised my wings had been clipped. I had to learn new ways. I'd heard of other wives being beaten and at that moment, in spite of the pain and humiliation, I had to try to do things his way. I lived under the constant threat of physical and mental abuse.

Mr and Mrs Hegarty proved to be wonderful people. I had entered their home as a stranger but in a few days I learned about family unity and love. Their support was really appreciated. However I realised they could do nothing to stop the abuse as I was their son's wife and it was improper for them to intervene. To interfere in the arguments and fights of a married couple was not the thing to do. It would be an infringement of Joe's rights as "he owned me". I had always faced trouble head-on and was not afraid to fight my own battles. I tried to protect myself and fight back but was battered to unconsciousness. Joe's parents gave me what I needed most — their love and

support. I was helpless with nowhere to turn for help. Physically I healed quickly. The cuts and bruises were barely noticeable and with the rest of the family I was looking forward to our first Christmas together.

The Hegartys were very self-sufficient and self-supporting in spite of the conditions they were forced to live under. Despite the low wages, the rations, and the obvious government control they had found a way to sustain themselves and maintain a decent way of life in spite of the regulations designed to disempower them. They grew their own vegetables, produced eggs from their chickens and had a daily supply of fresh milk from their cow. A mulberry tree in the backyard and a grapevine were also added. Christmas was wonderful, the whole family of siblings, grandchildren, in-laws and some extended family made the day exceptional. Joe and I were once again enjoying a short spell of peace and quiet.

Early 1953 saw us once again trying to recapture the love we had experienced before we became man and wife. I was surprised that Joe had arranged for me to go to the New Year's Eve Dance with his cousin Jack Bradley, the only person he would trust to take me. Since I loved to dance and Joe didn't, sending me with his cousin Jack was his way of saying "I'm sorry" after a recent fight. Joe was never one to say sorry, he would find any other way to express it. However I was not comfortable with going. We were home before midnight!

On the first Monday of the New Year Joe thought I might like to go to the Ration Shed with Carmen for the rations. Of course I wanted to go! However I was not about to show any excitement so I simply said, "If it's okay." I had adopted a subservient manner in my approach to everything and it worked. This marriage and its success were important and I would do everything in my power (as weak as it was) to keep it together. I didn't see our marriage as a hopeless situation. I wasn't about to accept defeat.

A day at the Rations Shed began in Mrs Hegarty's kitchen. Containers were checked for contents, bags from large to small were laid on the table. The bags were made from cloth, stitched firmly together by hand. Some were marked with the content name, with a large bag for sugar and smaller bags for other dry goods. In spite of the fact that the kitchen was overflowing with family and breakfast you got the feeling that the ration bag procedure was a task performed, regardless, each Monday. It could not be hampered or put aside till later as the rations were as important to us then as going to the store for groceries is now. Without notice Mrs Hegarty placed into my hands six bags, not large mind you, but carefully sewn together and marked for my use. Her beautiful smile, as she clasped her hands around mine still clutching the bags, assured me of her love.

At that moment my mind went back to another time

when a kind gesture such as this was shown to me. I was seventeen and had just had my first baby. It was customary, in the Cherbourg Hospital, for all mothers of new babies to arrange for a relative or friend to take their laundry out as the Hospital did not provide this service. I had not made any preparations (bit of a scatter brain, I was) and it was only after the birth that I began to concern myself as to who would do my washing. *Perhaps I'll send it back to the Dorm — someone will do it*, I was thinking even as the midwife drew my attention to two small children shyly making their way through the door. They needed to speak to me and the midwife had invited them to come into the ward. I wondered what two small children would want with me; after all it was a school morning and that's where they should be heading.

Shyly they said, "Mum said we have to pick up your washing this afternoon."

Talk about a stroke of luck! But who was "Mum" and what family was this? I was very surprised, however I did say I would have my washing ready.

"Wait," I said, "who's your mother?"

"Doris Stanley," they replied.

It was after 3.00 p.m. with school out when the Stanley children, Arthur and Nellie, arrived to collect the washing. They asked me to write down the baby's name and, to my surprise, as each article of clothing was returned to me they were embroidered with the initials C.R.D. (Cassan-

dra Robyn Duncan) which were surrounded with very small flowers. This wonderful mother of eight or nine children and her act of kindness will be remembered always. And now, as I looked at the ration bags, I saw the same act of kindness repeated. Such acts of kindness could not ever be forgotten as they are rare and hardly ever experienced.

As I took the bags I was really preparing myself for my first day of going to the Ration Sheds. In the years I spent in the Dormitory I had never been close enough to the Ration Sheds to witness any of its activities. This was the Camp people's area. There was no way that I'd be found at the Ration Sheds — it was always out of bounds for us Dormitory kids anyhow. However, there I was. Of course I was now a wife and a Camp woman. When Carmen and I, with Glenys in the stroller, arrived there was real market-place feeling. People were busily collecting their rations. I noticed a few were on their way home. I nervously approached the end of the line, remembering the animosity that had always existed between Camp and Dormitory girls throughout our school years. Almost every afternoon when school was out I was involved in a fight with kids from the Camp. I wondered if they'd be here and did I have to watch myself.

"Good morning, Mrs Hegarty," one of the older women called out. Others joined in and I felt good. I was being accepted as a Camp woman.

It was a long hot morning, the line was moving slowly, children were getting restless, there were babies and toddlers everywhere. I noticed the dogs getting agitated with each other, growling and snapping. It wasn't long before a great fight broke out between them. We quickly retreated and watched as the owners desperately tried to untangle them. As one or two were pulled out other dogs joined in, they were pelted with sticks and stones and anything else people could lay their hands on.

Always thinking ahead, I thought that Carmen and I could get to the front of the line while the others were dealing with the dogs. But back everyone came and little by little we were inched into our original place on the end of the line. There was a lot of laughter and fun as the dog incident was re-run, and then it was back to business. It was getting late with the clock moving towards 11.30 a.m. as Carmen and I moved slowly towards the front of the queue.

The dogs were resting after the exhausting exercise of fighting, and children were running around and playing games. The dogs pricked up their ears at the sound of drays entering the yard. These drays were drawn by huge draught horses. The dogs began snapping at the heels of the horses. The driver spurred them on to a trot while his dog, on the other hand, thought it was a game and ran from one side of the dray to the other, barking and snapping at the dogs on the ground.

"Grab those kids!" someone yelled, as anxious mothers tried desperately to rescue small children from being run down by the horses.

"Joe Hegarty Jnr — three," someone called.

I was in front of the huge windows of the Ration Shed and our name was being ticked off by a worker with a book. The boys behind the counter were waiting for my ration bags.

I turned away from watching what was happening and I saw three cups (that was a week's ration for Joe, me and Glenys) of sugar, rice, porridge, tea, sago and salt emptied into my small bags. Every family was entitled to the rations. They were often called "free issue". The Government gave them out to families in lieu of payment. These weekly rations were controlled by the government and could be withheld from families where the husband refused to work. It was evident to me that we would not survive without them — we were dependent upon those rations, they were vital to our very existence. The small wages Joe earned over the years were never sufficient to satisfy the shortfall that was required to support our family. My first day at Rations proved to be a day well spent although I did not catch up with any of the ex-Dormitory girls. There would be other times!

Chapter 3
On the Move

The weeks of constant arguments between Joe and me continued and his jealous rage was usually accompanied by a series of hard blows. It came as no surprise to me that Joe's parents wanted us to leave. Even as Joe passed on the message I felt that we were in a hopeless situation. The obvious question I asked was, "Where will we go?" Other things that were running around in my head I could not even bring myself to say, things like: "You are responsible for everything that is happening — I expected that you would look after us. You have no shame!"

"Dad has arranged for us to live with Uncle Frank."

I stared at him in disbelief. "You're not meaning old Uncle Frank from the hill?"

"Yes," he said.

"Why" I asked, "is there no other place for us to go to?"

"No, Dad has already spoken to him." I could not believe what was about to happen.

"The hut is small, how are we all going to fit in?"

Joe got angry when I asked, "Is there a lavatory? What about water? Where will we cook? What about the baby?"

Glenys was running about everywhere and I argued that there was no way I would take her to live on the hill. I insisted that he pay a visit to Auntie Maud Turner and ask her if she'd take Glenys until we found something else. Bill, Auntie Maud's husband, was related to Glenys' father, and they were happy to take her.

That evening after we settled Glenys, Joe's father drove us up the hill with the few possessions we owned. In the glare of the headlights I saw two elderly men waiting to greet us. I got my first glimpse of what their camp looked like. There were two huts, one each for Uncle Frank and Uncle Herb. I wondered what was going to happen to us, where were we going to sleep? We were taken then to the hut that was going to be ours. Uncle Frank, with the aid of his walking stick, proudly pushed aside the hessian that covered the doorway and showed us where we would sleep. At a glance I saw that it had a dirt floor and was just large enough to fit a double bed and a bench.

With a loud sigh I watched Joe as he entered holding a kerosene lamp with a globe that badly needed a clean. The glimmer of light it produced was barely enough to shed any light on where we were going to live — without elec-

tric lights and so far away from all amenities. Joe placed the lamp on the bench and walked outside to talk to the two old gentlemen. He asked as he left, "Do you want me to leave the light on?" I didn't answer as I was tempted to say, "Why?" His father drove off and we were left in complete darkness except for the lantern that was flat out producing any light at all. The double bed came with the hut, and the mattress had a strong smell of dog. After turning it a few times I made the bed up for sleeping. The hut was small, it was not built for more than one person. I wondered how earth Mr Hegarty had managed to convince Uncle Frank to take us in. Joe would not discuss the situation.

"Why did we end up here?" I'd asked earlier.

He hadn't replied or displayed any sort of feelings. There were questions I wanted answers to but I prepared for bed in silent anger. I listened to the muffled sounds of male voices as he sat outside at the fire talking to the uncles. I was as close to the galvanised iron wall as I could get.

When Joe came into the hut to prepare for bed I made sure my back was turned to him, I wanted him to think I was asleep. He sensed I was angry. I wasn't sure when sleep came. I awoke to feel something heavy over the top of me! Afraid to move I elbowed Joe in the back and whispered, "There's something on the bed!" He grabbed for the torch

and shone a light on the foot of the bed. I couldn't believe what I saw.

"Dogs!" I yelled. "How dare they?"

Four sets of eyes were looking at us, their owners not wanting to go anywhere else. I pulled my legs back, kicked as hard as I could and sent them yelping out of the door. As quickly as that happened the uncles were up, torch lights flashing around the place.

"Here boy," they called out to the dogs. Joe left the hut to join the search.

"Who's there?" they yelled.

"It's me, Joe-Joe," he replied. The older members of his family had been calling him by that name since he was a small boy.

For some minutes they all searched for the dogs and intruders but with no success. I saw the funny side of this adventure and had to restrain myself from laughing out loud. Joe finally joined me, it was so funny that the tension and anger between us had by now disappeared. We heard all about the night's episode over a drink of tea around the fire next morning, as the two Uncles were keen to tell the story of the intruders and the dogs.

I insisted on going for my own rations with Carmen who by now had become my small companion. I was able to share with her all that I felt. I was trying to keep up the charade of being happy while Joe continued his jealous tantrums. The uncles were greatly troubled and lost no

time in reporting us. After about four weeks we were on the move again, this time it was to my Grandfather's home. Without any consultation with me, Joe arrived home to tell me we were moving once again.

I asked the obvious, "Where are we going?"

His answer shocked me, "Dad asked your grandfather to take us in."

To me this was a ridiculous idea. It seemed as though Mr Hegarty was looking for a safe house for us and he could not be blamed for that. If only we had been able to talk about it.

Of course I was angry, again I was left out of any decision making. All we had to do was pack up and get ready to move when Joe's father arrived with the Mission truck. The Turners had been glad to look after Glenys for the past weeks and were reluctant to give her back, but she was ready and we were able to gather her and her gear on our way through. We were happy to see each other and I hoped we would not be separated again. We drove through the Mission, on past the sports ground, past the cemetery, on to the slaughter yard and then to Grandfather's. In the few weeks that we'd been married this was our third move — we could not have gotten further away from the Dormitory. This area was called the Baralbyn (like an outer suburb of Cherbourg). The house that Grandfather occupied was, over time, home to various families.

As we drove in I saw a well-constructed large home in need of a paint job. It had all the marks of once having been nurtured and nourished by large families. Later, as I walked around the yard with Glenys, I saw there were fruit trees badly in need of pruning, gardens that once had vegetables, a yard for chickens and a magnificent grape vine that had held its place for many years on a trellis that shaded the front entrance to the house. There was plenty of room in the main part of the house, a verandah, and a covered walkway that led to a large kitchen that would cater for the many children. The whole back of the house was protected by wattle trees.

We located Grandfather and Granny Ada at the back of the house. They happily spent their sleeping hours with their dogs in a tin hut that had two side walls, a back wall, a roof and a large fireplace. They said we could select any room in the house and we would all share the kitchen. As isolated as it was, it was five-star compared with our other accommodation. We could be happy here, and we were for a time. However that collapsed around us when some Mission workers were consigned to work at brush cutting close to the house. The abuse began again and, as always, it was committed in the privacy of our bedroom. I was forbidden to cry out! There was really no visible evidence that the abuse was happening. For the sake of our relationship and the fear of another move I managed to conceal hurt and abuse.

I really loved living there with my grandfather and we had lots of years to make up for. My old people, when they were not lazily relaxing by the fire with the dogs, would be about their own business. Grandfather married Ada Mac after my grandmother died and they had lived together for many years. They were ideally suited. Grandfather was the butcher for the Mission, he killed and dressed the beef and was in charge of its distribution — a very responsible position for someone his age. He was respected by everyone and was a man of high morals. The values he maintained in his personal life were clearly recognised by all who knew him.

I figured this was an opportune time for me to get to know him. I was his first grandchild, the daughter of his eldest (and what I learnt) his favourite daughter, Ruby. I don't know what I was looking for in our relationship, maybe some comfort to take away the heartsore feelings of hopelessness and discontent of what should have been the happiest time of my life.

Living in the secluded confinement of Dormitory life had not prepared me for life in the Camp. I was blinded by love, and although life in the Dormitory was controlled it was better than this. I wondered if the fact that we were now so far away from people and places we knew, away from any distractions that would give rise to his jealous outbursts, our marriage would have a chance of surviving.

One day I went over to the slaughter yard to witness Grandfather at work. I walked over with Granny Ada and the baby. I was surprised at there being so many people standing around. I was glad of the opportunity to talk to some of the folk waiting around. I figured they, like me, were the spectators.

"Are they here to watch the killing?" I asked Granny Ada.

I didn't hear her answer for we were both watching as Grandfather climbed up on the scaffolding above the concrete enclosure, preparing to shoot the bullocks. One by one they fell and he was down from the top to stab them. I watched in horror, this was not the place for small children. However I stayed long enough to watch as the guts (intestines) of the first animal were taken out. They were carefully put aside and I watched as they were cut up and distributed amongst the onlookers. Even as a Dormitory girl I was aware of the hankering our people had for guts. For many years this practice had taken place, and the guts were still regarded as a real treat — good tucker. It was some years later that a new Hygiene Officer, a white man, horrified at what he witnessed, put a stop to what he described as a very unhygienic practice. If you've ever been to the Baralbyn you'll know that the streams flow crystal-clear with cool blue water over white sands. The intestines were buried in the sand by the creek, to the delight of the Hygiene Officer but, as he drove off, there was a

rush to dig them up and share them. So the consumption of the running guts (as we called them), as far as he knew, ceased.

I left the area to walk back to the lonely house as the grandparents and their foster son, John, would be away for a few days. The house became my prison as I had no reason to go down to the Mission. The rations and the issue of meat were taken care of by Grandfather. The Mission killed two days a week and Grandfather was chief butcher and responsible for cutting up the beast and distributing it among the Mission people. He would have been in his late fifties then, and died of a massive heart attack at fifty-eight. It happened at Baralbyn; he was too far away to be saved. Grandfather and I did get very close because he loved to cook and the hours we spent together as he cooked our meals were important. I craved a relationship with someone of my own blood but it wasn't going to last. I didn't want my grandparents to know that I was being abused, but they were not stupid people. They were not prepared to put up with Joe's aggressive behaviour this time and, because of that, we would move again.

We hadn't been living with Grandfather all that long when Joe told me we were moving again. I was angry and, to be honest, I now cared less about what he would do or say. We were about to go further out bush.

"Look what you're doing to us. Is this how we should be

spending our lives? You're an idiot," I told him, "you need help."

Usually a slap in the mouth was what I could expect for defying him. I had no support, other than the little I got from family, nor could I expect any. Maybe we both needed help. I was afraid that this move would destroy me. I argued that it wasn't fair we were going further out bush. Once again I had to find someone to take care of Glenys, I would not take her further away from the Hospital and clinic. I would also lose Carmen, my little friend. Her love was one thing I could count on. I took comfort in her small presence and our relationship was being threatened by my constant moves. I had, by now, agreed in principle to leave Cassie with the Douglases indefinitely, as I didn't want her life to be constantly disrupted. She had never in her young life been exposed to any sort of violence. She and Glenys had not had any time together as sisters and I hoped they would bond with each other. Barron and Winnie Douglas were wonderful parents. Glenys would be safe with them. They agreed to take care of her for a while. It hurt sending her away for she was only about two years old. I was adamant this would be a temporary arrangement, I would not lose another child.

We'd always intended to take Cassie to live with us eventually and I thought a decision might be made at the end of Glenys' stay, but it was not to be.

I sat alone at Grandfather's house after Glenys was taken to the Douglases' place at the Camp. He and Granny had not come home. It may have been a long workday at the butcher shop, if so they'd spend a night at the Mission with other family members. I thought over what would happen to me now. I was gripped with fear. I had suffered much and was now at the mercy of my husband as I waited for the transport that would take us further out to where we would live. There was no one to turn to — no one to talk to. I feared for my life. It was getting late, darkness had fallen and there was still no sign of Joe. I was so lonely and unhappy. I began to think of a time when I was happy but those happy times were just memories.

I lit the kerosene lantern as the darkness frightened me. The dogs could sense my uneasiness and stayed close by. I strained my ears for sounds; my eyes were glued to the road as the fear of Joe's return left me in a state of great anxiety. All I could think of was I could not go on being married to him, I would rather die! I heard him as he rode up and even as he began to take the saddle off the horse I had decided what I would do. The threat of another beating was too much to bear. I ran away into the scrub, not knowing where I was going. As I got further away from the house I realised I was lost. I sat down, tired from running. There was no going back. I was sitting at the edge of a dam wondering what to do when suddenly I did the unthinkable, I walked out into the water with the desire to

drown myself. Ours had become an almost hopeless situation.

I went further and further out but the water got no deeper, at its deepest point it was just over my waist.

I thought, *I can't drown in this*. I realised then what a stupid thing I was doing. I was about to commit suicide. I waded out of the dam and sat feeling helpless. I knew I had to find my way back. Soaking wet I began walking. This is the hardest thing for me to write at this moment and I pause to reflect. The best thing to do probably would have been to walk away from Joe and never come back. But in spite of what I suffered, walking away was the one thing I would not do. It still hurts when I think about it. I avoid watching movies or reading newspaper reports that graphically describe the suffering of women and children in family violence situations.

I saw torch light coming towards me. I thought, *Why run? I'll just face up to it*. I was never a coward. Joe was coming towards me but instead of anger there was such relief in his voice that he had found me. As we walked back to the house he said, "Please don't do that again, you had me worried." And in the next breath, "Did you think you could get away from the best tracker in the Mission?" he joked.

As he helped me to remove my soaking wet clothes he asked, "How did you get so wet — there was no rain."

Up until then I had not spoken a word. I was so angry, more with myself than anyone else.

"I was trying to drown myself, wasn't I, but the bloody water in the dam wasn't deep enough, it only reached my waist."

I could see he was trying to hold back laughter and I too could see how funny and stupid it was. We both laughed and it was never mentioned again.

The next day Joe's father appeared in the Mission truck to transport us to our next destination. Frog's Hollow it was called. I was surprised to see Mrs Hegarty sitting in the front seat and she greeted me like she always did, in a very loving and caring way. Before leaving on the journey, I shared with Joe the news that I was pregnant and he was on cloud nine. His dreams of a son began at that very moment.

We seemed to drive forever, the old Mission truck wasn't the most comfortable thing to drive in. Finally we reached our destination. I was delighted to see another family living close by, and equally delighted to find out who they were — Willie Conlon who was once a teacher aide at our school, his partner Althea Sandow, a Dormitory girl younger than me, and their small children.

We womenfolk walked around with the children while the men unpacked the truck. Suddenly I realised that they were marking out a place where they would erect the hut.

"Oh no," I said to myself, "this is one time I'll have my way."

Mrs Hegarty and I went over to where the men were preparing to start. "I hope you're not putting the hut there," I said, "I want it under this large gum tree."

Mrs Hegarty shook her head, "No, not under the tree."

I wasn't about to argue with my mother-in-law and I noted Joe wasn't either. So I stepped back and accepted against my better judgment, and watched as our hut came together thinking that this was another decision that was being made for me. When Joe's parents left we settled into our home — a tin shack, but it was ours. I had some good feelings about this move.

It came about because Joe was offered a job timber cutting. Cherbourg had its own timber mill — it was quite a thriving industry. Joe and his partner, Willie Conlon, worked from dawn to late afternoon cutting down trees that were selected and marked for that purpose by the Forestry Department. It was hard work, they used axes and a crossbow saw. Often just two or maybe three trees a day were felled. The logs were transported by truck to the mill where they produced timber to build houses.

The work would last until the time our baby was due in seven months, and it was during this time I discovered that my husband was, indeed, a very talented and dedicated bushman. When he wasn't cutting down trees for the timber mill at Cherbourg he was teaching me how to

love and respect the bush. He identified animals and plants and showed skills in tracking both large and small creatures. On a large ant bed I was shown the diggings of porcupines, and trees that had the distinct marks of where possums had climbed the previous night. He showed me how to identify witchetty grubs by tracing the sawdust around the base of wattle and gum saplings. Even when we rested on the cool grass we listened to the sounds of birds and he identified them. Everything we needed to sustain this perfect relationship was here at the edge of the forestry reserve and I wanted it to go on forever. However, it was not going to last since I was due to give birth soon. I guess we were both going to miss this life, the tranquillity of our surroundings. Our good neighbours did nothing to interfere in our lives. Joe was absolutely over the moon as I became his student. This was his world and he took delight in showing it to me. Our baby was growing inside me and so were his dreams of a son to whom he could teach the ways of the bush.

Joe taught me about cooking in the camp oven, of baking bread in the hot ashes. I finally mastered the art of scone making, particularly the fried variety. While we were engaging in these activities the disputes came to an end for a time. It was hard to recognise that this was the same person. However it would soon end. Living in the bush was not without its troubles, I was heavily pregnant and had not visited a doctor for some months nor pre-

pared anything for our baby's arrival. I knew the time was drawing near when we would have to return to the Mission but, in the meantime, Joe was enjoying the pregnancy — even if my cravings caused him some headaches.

I had a craving for pineapples. Unfortunately they were not as readily available then as they are today. To satisfy my needs I remember Joe saddling the horse and riding more than four miles to buy me a pineapple. It was just the smallest pineapple. He proudly took off all the peel and sliced it up just ready for me to eat. I argued that he'd done it all wrong — I wanted to cut it in half so I could scoop the flesh out with a spoon. Nevertheless I enjoyed every mouthful, even chewing all the skin, which surprisingly did not give me a sore tongue. He obviously told the family about my cravings because when the rations came out on the truck my mother-in-law would send out a pineapple.

Mrs Hegarty's foresight also helped us in other ways. Her sense of imminent danger had led to the decision to erect the hut further away from where I wanted it, under the gum tree. One afternoon while I rested in our hut I heard a sound. It wasn't the wind blowing, or the sounds of birds, it was sort of a squeaking sound like huge branches rubbing against each other. Suddenly — out of the blue — the gum tree crashed to the ground, shattering itself into a million pieces. Branches large and small landed a few feet from where I was resting! Screams from

the Conlons' camp brought a group of forestry workers racing through the scrub to the camp. They were prepared for the worst possible disaster — they were carrying axes and other equipment. They were surprised to see me alive as I stood at the entrance of our hut and silently thanked my mother-in-law for her wisdom. The exact spot the tree crashed down was where I had chosen to put the hut.

The wonderful time we spent at Frog's Hollow had come to an end and preparations were being made for our departure. Bidding goodbye to the Conlons who had been great friends we packed our gear onto the sulky that Bill, Joe's older brother, lent us. We were both looking forward to the birth of our first son and we'd talk for ages as we lay in bed. Joe would not accept that this baby could be a girl.

"No," he'd say, "it's going to be a boy and he's going to look just like me."

Despite how much I'd enjoyed life in the bush, getting back to the Mission and civilisation was what I wanted more than anything and I prayed he would not be disappointed and that our baby would be a boy.

I climbed up on the front seat of the sulky and waited as Joe settled into the seat beside me. He looked at me to make sure I was comfortable and with a click of his tongue and a light tap of the reins we were on our way home. Not too far down the road the horse was spooked by a loud noise at the edge of the forest road and bolted. I

will never forget that ride, it might have lasted only a few minutes but to me it seemed like forever. Joe had to cope with my screams and threats that I would jump out if he didn't stop the horse. He used one hand to control the horse and the other to control me! When finally he'd settled the horse he climbed down out of the sulky to softly stroke her as if to reassure her that everything was going to be all right.

Then he turned to me, "What were you thinking of, trying to jump off the sulky? You didn't even think of your condition!"

He was angry and I started laughing, the whole episode was like something out of an old western movie. He joined in laughing with me but still he reckoned I was stupid. We survived that ride and I hoped that I could bottle the happiness that we had found. The family was glad to welcome us and Glenys just wanted to get back to chasing the chooks at the Hegarty home.

Chapter 4
Hegarty Babies

The wait for the baby's birth was longer than we expected. April came and went and we were into the month of May. This was not good, suspicion once again entered our lives. How was I to know why the baby would not come in April? It was the second week in May and the Murgon Show was in full swing. Joe's eagerness for his son's birth could wait. Almost everyone — and that included my husband — went to the Murgon Show. Those who stayed home included my mother-in-law, her grandchildren and me.

After we settled the children down for the night we sat on the front steps to watch people walking to and fro past the house. On Saturday afternoon lots of activities happened at the Show, with fireworks at the end. Almost the whole of Cherbourg went to the Show. Unlike most other visits to Murgon no permits were required. People used

whatever means of transport available to get there — the bus, Mission truck, buggies, sulkies, horseback or you walked. We had quite an interesting afternoon watching it all until dark. The Show was something not to be missed. The Saturday night events wound up with the finals of the ring events, buck jumping and bullock riding, and the Sharman's boxing tent was in full swing.

"You won't go into labour tonight," Joe had said and that was what he hoped.

I had to agree as I had no feeling that I would. However … what do you think happened? The children were settled down and everything was quiet as, finally, the numbers of people using the main road dwindled. The first contractions began. I told Mrs Hegarty that I was sure I'd have to get to the Hospital soon. We were the only adults with about half a dozen kids. With the house so far away from the Hospital all we could hope for was that someone would come walking past the house. Since the Hegarty home was a mile, and then some, from the Hospital as well as uphill all the way, we could not leave the children alone.

"Can you wait for a little while?" she said. "Someone might come along the road." We both knew that there might be a chance that no one would come as it was the last night of the Show. Mrs Hegarty sat quietly and I was sure she was praying. Wrapped in warm blankets we sat and watched and listened, just in case. The contractions

were very close together and we both knew these were critical times. I wandered back and forth, first from the back steps then to the front gate, hoping someone would come.

The pain was excruciating, but my waters had not yet broken. Mrs Hegarty's great faith and prayers were inspirational, but it was not enough. I was not sure anyone would come. Then from out of the night we heard voices.

"Someone's coming," she said, and I hoped it would be someone who could cope with taking me to the Hospital.

We peered into the darkness — there was no electric light — and it was not until they were almost to the cattle grid separating the garden from the main road that we recognised the couple. It was Auntie Rachael Saltner and her partner, Allan Arnold. Both Auntie Rachael and Allan were employed at the Hospital.

"Praise the Lord!" Mrs Hegarty said.

There wasn't time for big explanations, my large suitcase was given to Allan and we were off! After about one hundred stops on the way (the suitcase was handy for me to sit on) and such an agonising time, we finally reached the Hospital. You'd think with all that urgency and so much time walking uphill I would have had the baby on the Hospital steps. But the baby was not ready, I was placed in the labour ward and we waited and waited. The night staff came on duty — all Aboriginal nursing aides

— but no midwife. My water broke and I was in a critical state. This is how the conversation went:

"Someone go and get the midwife."

"She's at the show."

"Send the policeman for her."

Now the Show was four miles away and finding the midwife was like looking for a needle in a haystack. More time passed — no midwife! A little after midnight on Sunday 10 May, Mother's Day, the midwife entered the labour ward. She took a look at me and assured me nothing was going to happen for a while, then lay on the bed next to mine and went to sleep. I was told later that she'd had a bit to drink. The nurses' aides had a job trying to wake her up to attend to my needs.

I had a very difficult time giving birth to a very large boy. He weighed almost ten pounds. I was very lucky the doctor had been called to the Hospital to an accident patient, probably someone from the Show. The midwife proved to be too under the weather to do a good job of delivering the baby. She pulled and tugged. I heard her say, "The head's out, his bloomin' shoulders are too big." I was badly torn and in need of stitches. My situation was so bad that Matron got the doctor to look in on me and, after examination, he inserted almost thirty stitches into what was described as a "messy birth". Our rough-and-ready doctor was also a little under the weather and without a local anaesthetic he commenced to stitch

me up amid lots of screams from me. I was finally wheeled into the maternity ward but my new baby did not arrive for some minutes. The doctor was with him.

I thought, "I can't lose him, not now."

I lay fast asleep, to be wakened by a very happy father with the news of a son. He could hardly contain himself.

"We have a boy! I told you!"

The baby had been placed beside me as I slept and this was to be a magic moment. The rug was gently pulled away from the baby's face and together we looked at this little bundle of joy.

"He's white," were the first words out of Joe's mouth.

"He's pink."

As though he didn't hear me Joe asked, "What colour eyes has he got?" And as though the baby could sense what was going on he opened his eyes — they were blue!

"Blue eyes," he said. My poor husband. I was at a loss as disappointment was written all over his face. I tried to explain to him that I did not know myself why this had happened.

This joy that we long waited to share had suddenly been taken away. I watched as Joe walked out the door of the maternity ward. What had I done wrong? I knew what Joe was thinking and how this would affect both of us. Mrs Hegarty, on visiting, gave me assurance that everything would be all right. After she unwrapped the baby and looked him over she said, "He has his father's feet."

This remark gave me no comfort for I knew what Joe would be thinking — *How could I, a black man, produce a baby that is white?*

Fear once again gripped me. I could not explain this away except that maybe the baby was taking after me. I was not dark, I didn't know very much about myself or who my father was. Mr and Mrs Hegarty's first son, Bill, was fair with sandy-coloured hair and they later had a daughter who was fair-skinned and had fair hair. But did it really matter? Our son was white with blonde hair and blue eyes and no amount of talk could take that away.

However, Joe returned to the Hospital hoping I would understand that seeing his son and his colour had completely thrown him. He asked if we could change the baby's name to Norman William, a family name. We had already decided on Joseph Peter. This was to be Joseph Peter Hegarty the Third, he would carry on that name. When Joe finally came back to visit us and told me his thoughts on naming the baby, I wanted an explanation. His stuttering reply was that since this baby didn't take after him we should save the name for one that did, and we could call this boy Norman William. He'd obviously put a lot of thought into it. I was very angry.

"Are you saying our baby is too white to carry on your name?"

I accused him of being proud.

I was not happy but we finally called him Norman

William and not Joseph Peter as, Joe said, "We still might have a black son!"

In later years we had two more boys but we didn't get to name either of them Joe. Carmen had a boy before our second one, and named him Joseph Benjamin Hegarty.

After a few days in Hospital we were ready to take our new baby, Norman William, home. He was christened Norman Von Nida by the nursery staff as he was born at the time the great golfer was making headlines as a champion. All the way through Norman's schooldays he answered to the name of "Nida" or "Snider", and he is still called "Snider" by friends and family.

Taking the new baby home was very exciting. However, it was quite noticeable that we were taking up valuable space. Joe's sisters, Norma and Carmen, were older and needing more space, and then there were the three boys, Peace (named for an uncle who was born the day World War I ended), Peter and Matthew. Harmony reigned in our lives for a little time, but now there were four of us and we needed to move from Joe's parents' house. Where to? I didn't know.

I no longer spent my days wallowing in misery with feelings of hopelessness and anxiety. At last things were looking good. I wish I could remember when it all began to change. With the new baby to care for I did not notice that I was seeing less of my husband. His work with timber cutting was finished and another job came his way. I

was kept busy with the two children. There was no questioning why, after our son's birth, we were no longer embroiled in arguments and fights. Of course, I was the last to know my husband was having an affair and that the woman in question was having his baby.

Our Norman was a few months old when I discovered that Joe had gotten a young woman pregnant. I was sick to my guts, I had no idea how I would handle this. Once the pregnancy was discovered it was common practice then for the wayward couple to be confronted by the Superintendent. Joe and the expectant mother were questioned at length. On accepting responsibility, Joe agreed to pay maintenance until the child was fourteen years of age. That should have been a good time for me to seek revenge — confronting Joe with that would have given me sweet victory as he had no defence. However, since on many occasions I have had to confront my own indiscretions with my accuser, it seemed good to me to let Joe be his own judge. The baby was innocent. I did not forgive Joe for I wanted him to suffer. I needed to forgive the woman involved, and in doing that somehow it helped me to absolve my past, to blot out what wrongs I had committed. I spoke to no one about this decision of mine. Who was there to talk to anyway? I continued doing the best I could for myself and my children. I chose not to fight him, and began to live my life accepting arguments and criticism.

We spent the next few weeks with the in-laws but it was getting a bit crowded in that small room with two adults, Glenys and the new baby. The overcrowding disrupted our family life and there was a lack of privacy. The room we occupied meant the other family members had to double up. The walls of the house were not thick enough to drown out our constant arguments, we were not getting along that well. Again, I lived in fear of being hit, and I feared for the children's safety. I was getting worried about what would happen. Soon the parents would want us to go. I was definitely prepared for that, but I would refuse to go back to Uncle Frank's or even out to Grandfather's. I told Joe that the next place we moved to would have to be our own. I was a dreamer: I also wanted our own home.

Joe's parents were very generous to have kept us with them as long as they did considering they shared their house with Joe's three younger brothers and three younger sisters. It really wasn't a large house but then, of course, the Government didn't consider larger families when they began building houses in those early days. There were so few houses that young married couples needing a place were not even considered. Joe would shake his head from side to side whenever I'd mention our own home. Even though it appeared to be an impossible dream, I was always the optimist. His parents were also very anxious to see us settled in something of our own as Joe's persistent

jealous outbursts were enough to wear out the welcome mat. It was obvious that his father was not going to put up with too many more of these outbursts. I maintained the hope that once we were in our own home everything would be all right. That was my dream, but at that time it seemed an impossible dream; not many young couples on the Mission were being approved for housing.

* * *

The year was 1955, Glenys was going on five and Norman was two and we were expecting another baby. All during those early years Joe was fortunate to be in employment either on the Mission or with the Railways, Forestry or Council. I spoke to him often about getting something of our own to live in and even though he agreed he did not have any notion of how we would do this. Mr Hegarty Snr had some influence and would often be seen in the presence of the Superintendent and other influential officials. Larger families were taken care of first when it came to housing, the Superintendent decreed which family's needs were greatest. Joe's father calmly announced one night that we would be getting one of the smaller houses that were being built at that time. I could barely hide my excitement, but there was a catch! There could be a bit of a delay as there was a slowdown in house stumps being delivered from the sawmill. So, for work to begin, Joe would have to work weekends to dig holes for the house stumps and, not only that, he would be required to put the stumps into the ground.

His brother Bill and other family members helped. Although it took some weeks for the completion of our house of two bedrooms, kitchen and dining room, the waiting was worth it. The house was built next door to my Uncle Len and Auntie May and for the first time I would have members of my family in close proximity. I was able to interact once again with Grandfather and Granny Ada, and other family members would always be visiting. Our move into the house didn't cause any major upsets since there was just Joe, me and Glenys and Norman. There would be ample room. I recall standing at the entrance to the house thinking, *This is ours!* As sparsely furnished as it was, that did not matter. A wood stove was all it contained; the tap for running water was outside the back door against the wall. I could stand on the back stairs and without much effort turn on the tap when I needed water. There was a double bed for us, a single one for Glenys and a cot for Norman. The pots, pans and utensils were a gift from Mrs Hegarty's cupboard. We had no table and chairs so we usually sat on the back step to eat. One day Mr Hegarty Snr arrived with several pineboard boxes of different sizes. For the time being we used them to sit on.

After moving into the house our relationship did become better as there was that special joy of being independent. The house itself was just a shell. It wasn't sealed or lined and in winter we froze. Because there was no ceiling the corrugated iron roof rained freezing droplets of

water down on us as the sun warmed it up. The only way to get warm was to go outside to a shelter Joe built and where a decent fire could be lit. In summer, on the other hand, the house was a hot box even with the windows open. The windows were push-out wooden ones that were hinged at the top and had to be propped open with something like a broom-handle. They always caused us deep concern. Every piece of furniture was kept away from the windows for the sake of the children's safety. While Glenys was good at seeing danger, Norman was a virtual little monkey.

* * *

Mayleah was born to us on 26 August 1955. We didn't have the drama with her appearance that we had with Norman's. She looked for all the world like Mrs Hegarty Snr and was named for her. Joe was there for his daughter's birth and we were lucky that she was not born on our way to the Hospital. It was, once again, a long walk from our home and as the pain intensified the large suitcase we took to the Hospital was a place to sit until the pain passed. A long and tiring walk that was! The distance between our home and the Hospital seemed like miles. It was a painful walk and the times when Joe walked with me were just as stressful for him. As each contraction came we'd stop so I could sit down on the suitcase he was carrying.

"Are you all right?" was all he could say.

I was tempted to cry out, "No, I'm not!" but I didn't

have any energy to answer out loud. That particular long walk would've been taken by every woman on her way to the delivery ward. There was no vehicle available to transport any of us. A large port filled with the new baby's needs and someone to give support were all one could hope for.

Once at the Hospital I was about to lie on the bed in the delivery room when the baby decided to make an entrance. Her birth was too easy!

At this time Joe was employed at the Forestry and even though his wages would not have been more than about eighteen pound, eleven shillings and sixpence a fortnight, we were living a little more comfortably. I was getting Child Endowment Orders once a month and the Baby Bonus was what provided the baby's layette. The Baby Bonus, which was a Government payment of seventeen pounds for boys and fifteen pounds for girls, was useful for purchasing things from the Mission Store as well as other goods, unlike the Child Endowment. We purchased a cabinet and table and chairs for the kitchen. The Child Endowment, although introduced in about 1941 and payable to all Australian families, was now available to Aboriginal people living on Missions. However, it was not readily made available to us as cash, but could be used to purchase goods, on Order Forms, to the value of whatever you were entitled to.

Once a month on Order Day (it was not called Endow-

ment Day) the mothers in the Camp would arrive early at the Store and wait in orderly fashion until the doors were opened. Some would arrive as early as 7.30 a.m. This meant leaving smaller children in the care of older ones as this would free the fathers to report to work when the whistle sounded. The routine was arduous, we would sit on the ground waiting for the Store to open. Like the rations, the earlier you arrived the better. One by one we were served with our choices of Store goods and much of our Endowment allowance was spent in this way. At the end of the month a list of names, with what remained after the Orders were filled, was placed on a notice board for all to see and we could then register to draw the money out of the Office.

Right out of the blue, with another baby on the way, we were offered a larger home by the Superintendent. Since it was being built over the side of our street we accepted and watched with greatest interest as it took shape. It was a large house with three bedrooms, it had no ceiling or lining, but the windows were made of glass. There was a large kitchen with lots of space around the wood stove — that came in handy during the winter months. Our large washing tub fitted nicely in the space behind the stove so the children could take their baths there at night. The small verandah soon became our lounge room and we purchased some cheap canvas and had it enclosed. We moved into the house after the new baby's birth. This

time it was Duncan Leonard, and we were happy to be in a larger home as it would suit us should there be more children.

The Hegarty Jnr family was feeling really good now, and both Joe and I kept busy digging gardens around the house. Joe erected a fence to keep out the people who used our yard as a short cut. From late afternoon to early morning people who gambled at Muddy Flat often walked through our yard.

Duncan was born on 10 December 1956 and at this time the Cherbourg Hospital was without a doctor. Several women were taken to the Murgon Hospital about four miles away to have their babies. I went there for Duncan's birth and was brought back to Cherbourg the next afternoon. After a few more days in Cherbourg Hospital I arrived home and Christmas Day was spent at the in-laws. As always it was a fantastic time with lots of family and good food. Mrs Hegarty always put on a great spread. Surprisingly my mother arrived to spend Christmas Day with us, along with her friend Len, his mother and sister. At our house there was nothing to offer, so Mrs Hegarty graciously issued an invitation for them to join everyone at her house. Four more to feed was not going to be a problem! These people practised hospitality in a way that gave the impression that they were millionaires. Mr Hegarty earned no more than any other employee on the Mission but they were always willing to share.

Joe was lucky to obtain work at the Forestry again. We didn't see much of him during weekdays as it was many miles away. The other workers who were employed there travelled to work on a pushbike or rode a horse. Joe's wages, at the time, were eleven pound, eighteen shillings and sixpence. He was required to pay a percentage of his gross earning to the Welfare Fund. Three pound per week to the Fund increased to five pound per week. We didn't know about the Welfare Fund then, it was something we learnt about much later.

We were very happy for a time and four children should have been enough. However when Duncan was barely two months old I fell pregnant again. For the first four months of every pregnancy I suffered with morning sickness that seemed to go on all day, but the demands of everyday life had to be met. Glenys was now going to school but I had the three other children to take care of. Norman was so mischievous and every other day I was running him down to the Hospital to get a pea or anything small and round out of his nostrils! It usually happened on a Monday while the doctor was visiting. I once heard him say to Matron, "Not this Hegarty kid again!" I was happy he was not pushing foreign objects into his ears.

* * *

Joe's job at the Forestry came to an end and he was back working on the Mission. He had taken time off on a doctor's certificate due to some sap from the trees they worked with getting into his eyes. He was given some

time off but needed more. However the Superintendent tried to force him to go back to work, probably because of the compulsory contribution of part of Joe's wages to the Welfare Fund. Of course his refusal was taken as an irresponsible act against the Settlement rules. His contribution of three pound a fortnight into the Government fund was more important than his eyesight. After that Joe worked for less wages and this caused us some problems.

There was the endless struggle to put food on the table. I was still going each Monday for rations. I'd take the three small ones with me and, as Norman would not walk, he had to ride in the pram too. The weight of little ones plus the walk from our house to the Ration Shed was hard enough, but with three children and the rations to get home it would take so much longer. Our ration quota had increased considerably, so much so that Monday became rather burdensome. On Tuesday and Saturday there were the meat rations to collect. Also, conditions had not changed much and we were still without a water supply in the house.

I began each day by filling as many containers as I could to save the constant walk out into the yard where our water came from. Everything seemed so far away. To go anywhere meant walking, even the lavatory was out the back. As well as going to the Ration Shed and Meat Shop we were required by law to take the children for a visit to the Child Clinic each week. Here they were weighed and

given a body check, then we were issued with powdered full-cream Sunshine Milk and Aktavite. Since we were not issued with completely full containers we needed to provide empty containers into which a portion of milk and Aktavite were measured, according to the number of small infants in the family. Our days for Clinic were pencilled in and if we did not attend a police escort was sent to our homes. Sometimes, for me, it was a waste of time except for the free issue, as anything I got that didn't cost money was welcome. The Monday ration supply did not include milk, fresh or powdered.

We spent many years in that house. No doubt it was larger than our previous house, but we were forced to live without running water, the roof leaked as the ceiling was never lined, there were no taps or showers or baths or laundry for washing. The bare floors in the house had to be scrubbed at least once a week. Open fires outside were a constant worry and the halved forty-four-gallon drum was still being used for boiling clothes and heating water for baths.

One time when I was about four months pregnant with Moira, it was bitterly cold and we didn't have enough blankets. That year I joined many of the other women in collecting the large bags from the flour sheds. These gave great protection from the cold, particularly the icy-cold water drips from the tin roofs. I hauled six bags home and, after shaking all trace of flour out of them sewed them

together into what was called a "Wagga". We used it on our bed (was it heavy!) so that the children would have the extra blankets for warmth. There was also the awful smell of the bags to contend with as well the stuff that bags shed, which was strewn like dust among the other bedclothes.

In winter a fire was kept ablaze almost constantly outside at the back of the house. It served to keep the dogs warm on the cold nights and often I would hear family or close friends who were passing through our yard stop to get warm. It was during one of those bitter winters, while Joe and I were enjoying a sleep-in, that I was wakened by screams coming from the back of the house. I rushed out and found Norman, all of four years old, trying to beat out the flames that had almost engulfed his little sister Mayleah. At a glance I could see that she was badly burned. I smothered her against my body, putting out the flames. Her little body was trembling in my arms and as she sobbed I could hear her brother saying, "I didn't do it, Mum. I didn't do it!"

As Joe raced out he yelled, "I'll get the horse."

The horse was our only means of transport, it was kept in the yard overnight. I wrapped a coat around myself and ran with Mayleah towards the Hospital. I was almost there when Joe caught up with me. She screamed as he took her from my arms. As I sat waiting for the Sister to let us know how badly our little girl had been burned I

had the time to look at my own hands which were beginning to blister.

Mayleah was in a lot of pain, but comfortable when we left the Hospital to go home. The other three children were home alone and I can still see their looks of concern when we walked in the door. I gave Norman a hug to reassure him but all I could think was: *If it wasn't so cold this would not have happened.* We could not exist without the outside fire but from then on we were always very careful.

Mayleah was in hospital for some months — at least until the next baby came. We had planned to name the baby after the two young white nurses who had patiently and carefully attended our injured child. Our new little girl, so much darker than Mayleah and Duncan, was born on 26 January and her father called her his little Ginny, a name that is still used affectionately by her brothers. Well, here was Heather Shirley, the name we had decided on. As I was about to sign the register her father rushed in and asked if she could be called Moira Shirley. I did not question why, but it sounded good to me! She was a perfect baby.

My whole life was taken up with being wife and mother, and it seemed to me that there was no longer any trace of the person I used to be. My free spirit was completely gone as all my energy was used up trying to balance the needs of the children against those of my husband. The new baby was an absolute angel, no prob-

lems at all. Duncan was only thirteen months old when she was born and, instead of being able to put all my energy into caring for her, I was still taking care of his needs. He was still a baby and needed my attention.

Life in the big house had its ups and downs, and alcohol began its intrusion into our lives. Joe began bringing his friends home to finish off whatever grog they couldn't finish down on Muddy Flat. He expected me to stay up and help entertain the group, often until after midnight. My health began to deteriorate, my weight dropped from seven to about six stone. Problems arose and we all lived in fear of the violence they produced. As much as I could I was determined to protect my children, so much so that we had a system that worked whenever their father came home drunk. At the sound of a car pulling up at our gate everyone moved together, lights were turned off, and everyone went to their bedrooms, the older ones taking the younger ones. Throughout the whole manoeuvre not a sound was made. For years this scene was played out over and over again. All the children knew it was the only protection that we had against Joe's violence.

During that period our last son, Emmanuel Matthew, was born on 27 May 1959. I wasn't fond of the name but went ahead with it as it was chosen by Mrs Hegarty Snr.

When Manny was just two years old I suffered a mild breakdown. I was raising six children, desperately trying to budget the meagre wage Joe was earning at the time,

and trying to meet the constant demands of the children. Talk about enduring hardships!

I look back and recall the enormous efforts of women who, in the "white" world, would have been labelled heroines or pioneers. The hardships of "black" women are not spoken about or documented to disclose the tremendous effort our people made to sustain and foster family values. I feel privileged to not only have lived in the Camp but also to have shared some of their experiences. These women were tremendous role models, their composure in that almost ceaseless exposure to a life constantly under the scrutinising eyes of Government officials, whose objectives are only now beginning to be known, was inspiring. These were the women from whose lives I learned much, and they acquired this knowledge from their mothers — the knowledge of survival. So many of the older women, during my early years of marriage, told stories of the early Barambah days. These were stories of their families being forcibly taken from their country during the "removal" times. They talked, too, of the various ways the Government used to discipline and control them. Misery and disease caused endless deaths which resulted in children being left orphans, so that the Government took over the care and control of the children, placing them in the Dormitories. The women talked of forced labour, of being poor, of having their wages withheld or

getting no wages at all. They survived because they learned how to.

* * *

Without telling Joe I put my name down at the outpatients to see the doctor. I was in desperate need of help. My first course of action was to pay a visit to Doctor Monz who visited the Mission once a week on a Monday morning. He listened to my sad story but he actually was a very unsympathetic person. Not once did he look at me. I wanted him to look at me! I wanted him to see how much weight I had lost and how awful I looked. But he continued busily writing things down and it was Matron who then spoke to me, "You will be put on a course of tablets, half a tablet three times a day."

I had no idea what I was taking or what this tablet would do for me. All I knew was that I was absolutely knocked out for the next couple of days. A friend who worked at the Hospital identified them for me — Valium — and one of the side effects would be this washed-out feeling. I had far too many people depending on me — my husband (who was the least sympathetic) and the children, all six of them.

To the rescue came a dear neighbour, her name was Jessie Emmerson Wob (or Ya-Ya as Manny loved to call her). Along with her small daughter, Pansy, she walked into our house and first of all asked if I would like her to get my rations for me. I was filled with joy because never had anyone apart from my mother-in-law and Carmen

(who was by now working at the Hospital) ever offered me any sort of assistance. Jessie recognised immediately that I needed help and came every day. She became a very important member of our household. Her daughter Pansy grew up with our children. I was surrounded by such a lot of wonderful people. My in-laws supplied us with fresh milk, vegetables and eggs. And Jessie, being Jessie, insisted I rest in the afternoons before the kids came home from school, while she took the younger ones for long walks. She tackled my huge loads of washing and prepared meals for us all. She was just so filled with energy and talked a lot to herself. Manny could make her laugh at any time, he was the apple of her eye. She was tall and very thin with not an ounce of fat on her.

Joe was assisting the Hygiene Officer and with a gang of men spent a good deal of time spraying DDT around the homes to stop flies breeding inside, and to exterminate cockroaches and mosquitos in the summer. The flies were in great proportions, which caused gastroenteritis. It affected small children and almost every house had lost a child. The Hygiene Officer, while inspecting our home, spoke about the importance of cleanliness. We were all advised to give our children condensed milk to drink as it was less likely to become contaminated. Joe saturated our house with DDT, even under the house. The dogs refused to sleep there but not one of us saw any danger in the practice.

Nearly all our babies were fed with Sunshine full-cream milk. Why we were asked to switch to condensed milk I don't know — instructions such as this were followed without question. What nutritional value was there in a can of condensed milk and why not continue to use the powdered milk? It should have been obvious that, with the weekly spraying of DDT, the flies, which were always in plague proportion, had to have a lot to do with the onslaught of gastro. Rubbish lay at everyone's back gate to be collected once a week. Sanitary workers took away overflowing drums of human waste, also once a week. A large family could have two drums to be collected but, whatever the number, it was once-a-week collection. Without electricity, in unfurnished homes without kitchen sinks, minus laundry and bathroom, a lot of used water was thrown into the yards. Every house had one tap at the back steps that supplied water for the entire household. Our men and women worked hard to get some control over this epidemic but, unfortunately, not before a lot of lives were taken.

With so many babies going down with the gastro we thought ourselves lucky until our Manny was struck down. Days and nights Jessie and I took turns keeping a watchful vigil at the Hospital. We watched with sadness as the babies that didn't make it were taken away in the morning. Often times their mums had fallen asleep and were not aware of the baby's death. We felt it would not be

long before that happened to our little boy. His small arms and legs were like matchsticks, his stomach was puffed like a football. Joe continued his work spraying DDT. Granny Ada sent word to me to put a pinch of salt into Manny's next bottle of boiled water. I would take a chance on anything, and I did. He began to improve and it wasn't long before we had him home. The epidemic had passed but I believe that we lost over twenty babies at Cherbourg.

Chapter 5
A Few Steps Forward

As my health improved (I gave Valium away!) I was very aware that unless I took some drastic steps to improve the way we lived we would be subject to all the problem sicknesses that were going around. To make things a little easier for us all I began thinking that we might buy a fridge. I saw an advertisement in a magazine for a refrigerator and I was anxious show Joe that having one would not only save us money in the long term but would also provide healthy food for the children. I tried a few hints, then one day I came right out and said, "I think we should buy a refrigerator."

The look he gave me was one of disbelief. I was to see this look every time I brought up the subject of improving our living style.

"What! You have got to be joking."

"No," I said, "I'm not."

"How are we going to pay for it?"

I'd learned early that I should never come to him about anything without a plan. He went on to remind me that his wages of one pound ten shillings a week, before deductions, could barely cover our living costs, so how could we afford a refrigerator?

I laid out my plan. I would go into Murgon and talk with Mr Caswell who owned the electrical shop. I might be able to make a deal with him. The fridge was not discussed again, not until — that is — when I brought back the good news that we could have the fridge at one pound a fortnight. Joe hit the roof!

"How are we going to survive on ten shillings?"

Of course I had a plan. But it wasn't until the day the refrigerator was delivered that Joe began to relax a bit. The children were so excited as Mr Caswell showed us how to fill the tank with kerosene, how to trim the wick and what height the flame should be kept at. We all waited patiently for the little freezer compartment to begin its work.

"Well," Joe said, "now we'll have ice and cold water."

He insisted on making the first payment himself so with all his pay in his pocket he went directly into Murgon. But, he thought, first he'd buy some groceries *then* pay for the fridge. He came home late that night and I knew something was not right as he came into the house and placed the groceries on the kitchen table. As he

looked at me he definitely knew what I was thinking: *Too many groceries!*

"Next time," he said, "you can pay the fridge. I spent too much on the groceries and had nothing left to pay Mr Caswell."

Fortunately Mr Caswell was willing to wait until the next payday, but we would be left with a bare cupboard that week.

Joe's answer to any crisis was to get on a horse and go hunting, leaving me to worry about having no money. The next payday was two weeks away. After a successful bush hunt Joe arrived home on Sunday morning with porcupine, possum and a bag of fish. He unpacked everything and, as was his usual fashion, he started talking about who we would give fish and tucker to."

I interrupted him and said, "Everything goes in the fridge for now. We're going to let people know that we've got fish and tucker to sell."

With a look of sheer horror my husband, after taking a deep breath, said, "What? You can't sell to our people. Blackfellows share everything, bush tucker and fish."

"Not us!" I said to him. "We have the fridge to pay for."

Into the bedroom he went, muttering, "I won't get any sleep tonight."

By the time he got up next day we'd sold the lot and I was prepared for him to say, "How could you sell bush

tucker and fish to our own people?" Instead he asked, "How much money did you make?"

It was enough to pay for the fridge and buy a few groceries. Joe hadn't heard the end of our money-making schemes as our oldest son, Norman, informed his father that he was going to sell iceblocks for a penny each to the other kids. His own sister and brothers never did get to taste those iceblocks. He took charge of selling and refilling the little iceblock trays and, as milk was in good supply, he'd make up chocolate milk ice blocks as well as other flavourings. Those pennies were helpful for household expenses. Norman had all these schemes for making money, and became a champion at playing and winning marbles at the big games that were held in the Broadway. Our eight-year-old, wearing a patch over his lazy left eye, just kept winning. Whenever he was missing from home after school he could be found at the Broadway as he began challenging grown men! He had a big milk tin that he kept the marbles in and often I would hear the tin being tipped out on the bed where he'd be wheeling and dealing with other kids as they bought back their favourite marbles with cash that went into the tin too. He also sold soft-drink bottles, sometimes walking the four miles into Murgon on his own to do so.

The children and I sold meat pies. With an old mincer I'd make mince with some of our meat ration and turn it into very good pies. Our market place was the gambling

school which took place over the weekend down on Muddy Flat. The pies were sold for sixpence each. Norman said that if he took a billycan of tea down he'd sell that too! I also put my hand to sewing, making panties for small children. They were all hand-sewn and the material I used was from cotton dresses and skirts purchased from second-hand sales. I surprised myself that I should turn to sewing as it had been my most hated lesson at school. Also, tomatoes from our vegetable garden were very popular and sold well. We kept at it because now we had a refrigerator to pay off and kero had to be purchased regularly to keep it going. Keeping the fridge free from soot was another of my jobs, otherwise we'd have a kitchen filled with smoke. Those years were the toughest I'd ever experienced, tough enough to wreck lives and tear families apart. However the goals I had set for us made life livable.

Once again my health began to suffer. My weight was down to six stone again and I looked a mess. There was never any time left over for me, and at the end of the day I would be so exhausted that our marriage was suffering. I had no stamina left to try and help Joe out of the mess we were in. He blamed me for his drinking, and his violence became more severe. I didn't even bother trying to disguise the black eyes or the bruises and cuts — they'd soon be back again. The pressure was on to keep up the payments on the fridge and I was making more pies and sew-

ing by hand well into the night to keep up to the orders for the panties. I made dresses for the girls as well. Jessie Wob was still my number-one helper and she tried as much as possible to take some of the pressure off me.

I had been experiencing some dreadful headaches and I thought I'd put my name down to see the optometrist who visited the Settlement about once a year. As I entered the Welfare Hall, I saw the "eye-man" with his equipment set right in the centre of the hall. That visit left me very bewildered for, as I approached him, he spoke to me as if he had known me before.

"Hello. What are you doing here?"

First of all I looked behind me to see if someone else had followed me in.

He spoke again, "How long have you been living here?"

I was taken aback and I replied sharply, "I've lived here all my life, off and on. You don't know me."

"I'm sure I do." He looked up my name and was satisfied that he didn't know me but stated that I was a dead ringer for someone "out West". I was intrigued to say the least. He thought maybe I had a sister out there somewhere. Strange as it was, I was to hear this same thing over the years from others. When my Mum and her partner Len began paying occasional visits I ran the story by her but my questions were met with silence. She had no intention of discussing it and, at that time, I didn't even know who my father was.

A pair of reading glasses fixed the headaches but I began to experience lots of pains in the stomach and constant bleeding. I was very afraid of getting pregnant again and took this as a sure sign that, at least for now, I wasn't. I endured this ailment for some time but, finally, a very frustrated husband strongly insisted that I go and put my name down to see the doctor. I wasn't too keen as Doctor Monz and I had had quite a few run-ins over his treatment of one of my children. When Moira was about five years old pneumonia hit the Mission and a lot of children went down with it. The morning she was released from Hospital she had a high temperature and looked for all the world like a rag doll. I sent for Joe who brought along the Hygiene Officer and he confirmed that our child should not have been released. On my behalf he contacted the Office and I was permitted to once again have her admitted to Hospital.

After examining me Doctor Monz told the Matron to admit me for a curette. I had no idea what that meant or indeed what he was going to do. There was no explanation, but I understood that I should follow instructions otherwise I would get a visit from the police. I spent the Sunday night in Hospital with Grandma Hegarty taking the older children. Jessie cared for Manny and Auntie Queenie took Duncan. Monday was the only day of the week that the doctor visited the Hospital to see outpatients and it seemed a very long wait. I had been prepared

for the operating theatre and I lay in that white room wondering what was about to happen. Finally the doctor and Matron came in and the Sister placed a mask over my nose and mouth saying, "Count backwards from ten." I could feel myself slipping away but I still felt a pin prick down below.

I wanted to cry out, "Not yet, I can feel that!"

I heard the Doctor say, "How many children has she got?"

Matron's answer was, "Too many!"

When I awoke it was all over, and not one more Hegarty baby was born to us. What did he do? I was never told what the procedure involved. I would have liked to have known. Why would I question someone in his position? It could result in me being taken to the dreaded Office! No one dared question the doctor. However, my health improved.

Chapter 6
Cherbourg Weekends

Our weekends began to improve and became more pleas-
ant and, since hunting and fishing were what Joe was fond
of, I agreed to go out with him. We'd not had time to do
anything like that for ages and other couples were doing
the same thing. I knew the routine: Friday, about lunch-
time, the dogs had to be put on the chains and were not to
be fed. I baked damper and brownies and we'd have meat
from the butcher shop on Saturday morning. The wicks
of the small fat-lamps were checked. Saturday morning
the horses were brought in and then there was the ride to
the Store to buy batteries, bullets, tobacco and matches.
The rifle had to be cleaned and the sight fixed. The dogs
reacted noisily to the click of the rifle. Then Joe called to
the kids to let the dogs off the chains, the horses were sad-
dled, food packed, children taken care of, and we were
ready to go.

Mick and Peggy, our dear friends, were early movers. They'd go by sulky and their old Taffy strutted out with his gold mane flying. Des and Angeline often rode with us and we'd spot Esky and Molly going up along the Wondai Road. Charlie would be sometimes on his own or sometimes with young Matthew, and always the old hunters would be there moving out at the same time — each one an expert. They'd always hunted and fished to provide for their families. Often we would meet at a designated spot with the men swapping yarns, bullets, tobacco and worms — but never their dogs.

Each man owned up to three dogs and each animal had its own special skills, it might be a good "porky" dog, a "possum" dog, or one that could find wild turkey. Amazingly, the dogs very rarely got into a big fight and they sat patiently behind their masters, partly asleep but always waiting for the signal to move on. We women watched our men proudly, laughed at their stories and knew when they were stretching them a bit. The memories of those days are still very vivid and I recall that we went to places named Box Flat, Fishers Dam, Plum Tree, and Four and Six Mile.

As the kids waved us off on these outings I never once doubted that they'd be well taken care of. Their Auntie Carmen was a favourite, and though very young she took good care of them. The Mission, in those days, was a safe place to live and there's often talk now of the days when all

that was needed for safety was a good house-dog. Families would sleep with open doors and windows.

When we went out bush I have to say that a horse was never my favourite form of transportation and, in fact, I would have preferred not to ride at all. Joe would provide a tame and gentle animal named Beauty, but he was short, stocky and cunning to boot. I'm not sure that Beauty liked what he saw because as I mounted and settled in the saddle up would go his ears and, with a swish of the tail, we were off. Beauty stepped out with a smart and confident walk while I, on the other hand, was terrified.

"Don't let the horse know you fear him," Joe would say.

I could hear the echo of those same words from a time when I was sixteen and some of the Dormitory girls were being taken for a horse ride. I was a bit of a show-off and offered to ride one of the horses. *Anyone can do this*, I thought.

The lead horse and rider went ahead and we followed. Everything was right — or so I thought — so I clicked and the horse bolted up around the Hospital corner and past the tank stands. It was Saturday and the Fruit Man had his truck parked under the shade of the huge stands and there were people everywhere. I couldn't pull the horse up and the more I screamed the faster he went. People scattered everywhere until, finally, Dudley Collins caught up with me and managed to stop the horse.

"I'm getting off!" I yelled.

"No, you're not," he said. "Stay where you are and don't let the horse know you fear him."

Immediately I replied, "I *do* fear him and I don't care if the horse knows it or not!"

So here I was again, but putting on a brave face and hoping that Beauty would never know how scared I felt. After a couple of miles of riding I'd had enough and I believe the horse had had enough of me too. I could not get him to move faster no matter what I did, and Joe seemed to be getting further and further away.

"Wait for me," I called out for the umpteenth time, "this horse won't move along."

"Kick him in the guts."

"No, he'll buck."

This useless chatter went on until, finally, we reached our destination.

Now, everyone knows that riders get off their horses by putting one foot in the right stirrup then throwing the left leg over the horse's back, and landing with two feet securely on the ground. Well, that's what they do in cowboy movies! So this poor girl, in great agony, threw one leg over and then rolled down onto the ground.

Joe cracked up laughing. "Beauty's looking at you," he said.

"Yeah!" I muttered. "Thank you very much."

Well, you'd think that the ride home would be exactly the same story, but no, that little black beauty left every-

one else for dead. We got home in record time and then, instead of calling out, "Wait for me!" I was calling, "Catch up to me!"

After trying it a few more times, however, it was clear to both of us that horse riding was not my thing. Of course I was disappointed, because it had been my chance to show the family that I was one of them. However, it was obvious that I wasn't going to make it as a rider. The whole Hegarty family were very competent riders and had been riding since childhood. Though we continued to go bush and to the creeks for fishing we had to resort to walking.

Often in the late afternoon or early evening with the dusk falling we would sit on our front steps enjoying a cigarette. The sight of a full moon would excite Joe — not that he wanted a romantic night — all he could think about was, "Good night for hunting, Mum. Come on, let's go and get Bess and go for a walk." As well as our own hunting dogs we would pick up Bess, a golden-haired setter who was one of the best possum dogs around and belonged to Joe's father. When you're young and in love, a walk in the bush might seem romantic, but after a day of taking care of chores and kids I'd just want to go to bed.

Bess didn't walk, she ran and ran and ran. Her hunting skills could outstrip any of the other dogs, and if she found a possum up a tree her persistent barking could be heard echoing through the bush. Joe and the other two dogs would take off with me bringing up the rear. I'd be

falling over dead trees and branches, stumbling down gullies, panting up small ridges and all the while calling out, "Wait for me." I'd stop to hear Joe's voice, "Stay where you are, I'll come back."

I'm no heroine, and as I'd peer around I'd see that it was very dark among the trees except for the small beam from my torch. From previous hunts I knew my safety would take second place. It was more important that Joe kept up with Bess.

"I'm coming, I'm coming," I'd yell.

By the time I'd catch up Joe and the dogs would be resting beside the tree and looking pleased with themselves. Joe would pluck the fur from the possum and stuff it into his boots, it was always bitterly cold.

We only ever wanted a couple of possums so we'd soon begin our walk home, and getting home sounded good to me, but if Bess wasn't with us we'd pause for a few minutes so that she could catch up.

Joe would say, "Listen," and we'd hear her echoing bark.

"I've gotta go back to her," he'd say, knowing only too well that if he didn't she would just sit and wait.

I simply wanted to go home so I wasn't going back. Leaving me with two porky dogs, Rover and Smoky, Joe would return to find Bess. After a while she would come bounding up, almost knocking me over. Bess was beautiful and a real show dog. However, she became the greatest

possum dog and would run and hunt all night if allowed. Sadly Bess wore herself out and went missing for days. When she was found it appeared that she had died on the bank of the creek and no one knew what had caused her death. Since dogs were important to family life their loss was felt as much as if they were humans.

Joe's beloved dog Rover, that he raised from a pup and that was his constant companion, could easily have taken over our home had I not objected strongly to dogs lying around in the house. They loved each other very much and often late at night Joe and his dog could be heard in playful games in the yard. Rover was never a vicious dog, but one afternoon some children came into the yard to play and Rover took a great piece out of a girl's leg. Joe held firmly to the opinion that a dog should be destroyed if it attacked anyone. The child was taken to Hospital. When Joe arrived home from work I told him what had taken place. I left him to ponder his next move. I watched as he took the rifle and Rover up over the Dipyard Hill, the dog — thinking they were going hunting — ran beside him. It was some time before Joe arrived back home, alone.

Chapter 7
Changes on the Mission

We'd been told that a sewerage system was to be put through the whole Settlement. This was good news and there was a great amount of talk throughout the whole Camp. We'd have showers, laundry, a modern toilet system, and water laid on. We talked about it at the Ration Sheds and at the Store on Order Day. It was going to revolutionise the whole place and maybe this would be the start of many changes.

For such a long time the old well, on the way to Muddy Flat, supplied spring water for many of the residents for drinking and washing. One of the changes that took place was the blowing-up of the well that was then filled in. People talked about it being a shame since the well had been a source of good spring water since the Barambah days. Living in the Camp for ten years in the absence of easy access to water had been a real nuisance. While the

work progressed we put up with the inconvenience of dust and mud, open trenches and the further stress of trying to keep the kids at a safe distance while work progressed. After school the kids played around the open digs, the trenches very deep in some places. By 1961 the installation of the sewerage system was complete.

At the back door of our house they had to dig down very deep so planks were placed across the trenches to enable us to reach the lavatory. At one stage the operations came to a stop due to rainy weather. It rained for days and I was concerned that the trenches were beginning to fill with water, there was mud everywhere. It was dangerous using the plank bridge to visit the toilet or reach the back gate, but the kids thought the slipping and sliding was good fun.

During the wet weather we planned to go down to the Hall where a children's show was playing. It was still raining but the children were filled with excitement; they were all fed, dressed and raring to go. When we were making sure they were all ready we discovered that Duncan was missing.

The older kids went into action at once — we first of all searched the house but he was not there. "Duncan!" you could hear them calling out. We were all in a state of panic and our frantic running around encouraged our neighbours to join in the search. There were torch lights everywhere and, as word got out, people from the Hall joined

in. They searched the trenches that were all over the Mission and I was sure that Duncan had drowned. With tears in their eyes the kids were seated at the kitchen table when Auntie Barbara Stewart came through the door. I tried to be strong for their sakes but at the sight of Barbara I broke down. After a few questions she proposed that another search through the house wouldn't hurt and — thank heavens — we found him asleep under the double bed. The search was called off, we thanked everyone and since it was too late to go down to the Hall we all went to bed. Everyone warned him that if he did that again — "look out!"

Once the work was finished and those trenches finally filled in, we had water and, not only that, we had a toilet, laundry and a shower just a short walk outside the kitchen door. So far the taps had not found their way into the kitchen, where no progress had been made to upgrade the conditions we lived in. We were still without benches, cupboards and sinks in the kitchen, and the homes we occupied were still not lined or sealed.

There was still the routine inspection of homes in the Camp by Government officials with careful attention to reducing the flies, mosquitoes and other vermin. Breeding places for these insects were sought out and fumigated with DDT. The Government was big on hygiene and sanitation and they had the Baby Welfare Officers visit our homes on a regular basis. We were required to have our

home ready for inspection at the whim of the officials. A thorough inspection of the condition of the homes we occupied for years followed by some changes would have improved living standards for us.

In the year of 1961 we were checked for worms, both adults and children were part of this great survey. Little plastic containers were delivered to every household with each person's name clearly written on them. We were given two days to put goona into them, and then they would be collected. Treatment was given in great doses of worm medicine followed by a handful of boiled lollies. Because the medicine was so vile the children had to be restrained in the Hall and forcibly dosed. If the first dose was spat out they were held down for a second or third until a full dose was swallowed. It caused my little Mayleah such intense distress that just seeing the medicine or smelling it would cause her to become violently ill and vomit until nothing was left in her stomach. Not even the promise of boiled lollies was enough to sweeten the deal. Even now, all these many years later, she still hates boiled lollies. That treatment for worms has had a life-long effect on her mental state.

I remember (and many of the old residents of Cherbourg talk of it still) that the Government policy to rid the place of worms did not stop with worm medicines. The Hygiene Officer had orders to kill off many of the dogs. Aboriginal people and their dogs have an almost spiritual

connection. Each home would have at least three dogs and most were used for hunting, though others were companions or just house dogs. Great honour was lavished on a good hunting dog for it was a prized possession. There was never any focus put on particular breeds, but they were protected by their owners and an unwritten law existed that you did not take a man's hunting dog without permission.

The order to kill off the dogs brought a great deal of grief to owners. The Hygiene Officer, who was ex-army, shot any dog, anywhere, anytime! These killings were witnessed by many children. When the Hygiene Officer was around some people would take their dogs up into the scrub until late afternoon before bringing them home again. Even though the situation was so stressful, since it happened on a fairly regular basis, people found time to laugh, saying that the dogs, on seeing the man with the gun, took themselves to the scrub without their owners. Sadly, the dead dogs lay around the streets until their bodies were picked up by the men on the drays during their weekly rubbish run. Follow-up work included more worm medicine, more testing and more killing of dogs.

The spraying of DDT continued on a regular basis. Joe was back in the Mission, working with the Hygiene Officer as his leading hand. He mixed and filled the spray cans with the substance and along with other men carried the huge tanks on their backs. The only protection against the

pesticide coming into contact with their bodies was a po-
tato sack that was placed between the tank and their
backs. His clothes would be soaked with DDT and they
had a horrific smell. It made washing very difficult.

<p style="text-align:center">* * *</p>

It was one Saturday morning when we were having our
regular weekend visit from Auntie Queenie and her hus-
band Dick. He worked at the farm across the creek so we
were the closest people to them for a drop-in visit. Joe
made some tea and we talked about their son Frankie who
had been living with us after leaving the Boys Dormitory.
I watched as Auntie picked Duncan up from where he was
sitting and placed him on her lap. I'd been having prob-
lems dealing with him, but he loved the stories she told
him about the cows at the farm and the new kittens they
had, and by the end of the visit he was invited to spend
the rest of the weekend with them. He was three years old
at the time, Moira was two and Manny one year old.
Duncan loved to visit the farm with the Barneys and it be-
came a regular thing. I'd watch as they moved off with
Duncan sitting proudly on Dick Barney's shoulder.

The farm and Auntie Queenie became Duncan's week-
end retreat. Until he went to school, Dick and Queenie
Barney were his other mum and dad, so much so that he
called himself Duncan Barney. My mother-in-law,
Mother Hegarty, also features among my good friends,
our relationship was very special. She knew that her son
was not perfect. When her family moved from down at

the gate on the road to Murgon and into the Mission, we both enjoyed regular visits. Mrs Hegarty had taken on the care of her granddaughter, Pheonia, who often spent time at our house playing with the girls. Cassie also was spending more time with us.

After months of denying ourselves and our children some basic luxuries, the payments for the refrigerator had come to an end. Joe was relieved. However, further planning on my behalf was to send him into more of a frenzy.

"Now that we've paid off the refrigerator, I'd like to get a washing machine. We've got a brand new laundry, washing tubs with water laid on, so we should buy a washing machine."

"Why do you need a washing machine?"

What a stupid question! I was handwashing for seven kids and two adults and still using the half forty-four-gallon drum as a boiler. I argued my case with great ferocity.

All Joe's arguments, as usual, fell on deaf ears. I once again called upon Mr Caswell and signed up to pay off a washing machine. I remember it was a Simpson with a wringer attached. My washing day was cut in half. Of course, my man showed it off with pride when anyone visited us. It had its problems for the children, though, as little fingers would almost be crushed in the wringer. Jessie Wob was still with us and took great pride in keeping the machine polished and covered. Jessie was my one stabilising, steadfast, solid-as-a-rock helpmate for many years

while the children were growing up. She asked no questions, even at those times I appeared out of my bedroom with blackened eyes. She gossiped about no one.

I had never understood why Jessie insisted on coming to our house those five days a week (no weekends unless an emergency arose). It was not because she was being paid for she demanded nothing from us. We shared whatever we had with her and Pansy, so maybe she needed us as much as I needed her. I was very blessed and counted myself fortunate to have Jessie as part of our family. She and Manny were inseparable.

Jessie was once a Dormitory girl, perhaps that was the connection that brought us together. I was too young to remember just when she came to the Mission. On collecting data for this book I discovered that Jessie, aged twelve, arrived with younger sister Pansy, aged ten, from Augathella, along with their dad and Auntie Minnie, in 1931. The girls were placed in the Dormitory. It must have been a traumatic time for them both, not only were they taken from their home but they were separated from the two people who had shared their young lives. I was too young to know either of the girls as more than ten years separated us. I'd like to think that what connected us was that we, that is my Mum and I, suffered the same fate and we were Westerners too, coming from out Mitchell way. Jessie's sister Pansy speaks with great respect of my mother and how Mum took care of her and Jessie in those early

years. Mum would have needed good friends as in the years to come she would lose me to the system. My separation from her care was very hard to take. I've heard stories of a number of young women brought in from the West and how they formed particularly close friendships.

* * *

Joe and I had been married for about twelve years, and in those years he showed a lack of appreciation of me. We communicated less and less. Rumours fly thick and fast in a small community like ours. He was already paying maintenance for a child he had fathered outside of our marriage and the rumours had him in other relationships as well. My life in the Dormitory had taught me how to bottle up emotions, so our marriage survived in spite of the affairs, which, of course, he denied. But I knew better. I was prepared to remain in the marriage because any affair he had was short-lived, and while he played around I enjoyed the respite from arguments and the repeated violence.

Do I sound like I didn't care? Of course I did! I'd often look at myself in the mirror and the reflection that stared back at me was almost lifeless. I kept losing weight and the only way that I could possibly describe myself was that I looked like something the cat dragged in. With all the pain and emotions I had suffered I convinced myself, for the sake of peace and quiet as well as the children's mental stability, that I would simply ignore all that happened outside the house. I was of the opinion that I had made my

bed and I'd have to lie in it. Another sad event in my life at that time was the death of my beloved mother-in-law. I'd almost gotten over the unexpected death in childbirth of my friend, Marcia, and now this second death. The whole family was devastated.

Mother Hegarty had spent a few weeks in Hospital but wasn't responding to treatment. I remember, on a couple of visits to the Hospital, she'd asked Joe and me to look after Pheonia should anything happen to her. Of course we would, but we were convinced nothing would happen. For days after she died I tried to comfort Joe who loved his mother very much. He kept asking, "What are we going to do?" I also wondered what we would do. Of course Pheonia came to live with us, she was just nine years of age. I was glad that during much of the time she had lived with her Granny she had been a regular visitor to our house. She and Mayleah were the best of friends, with Pheonia the elder by one year. The death of Mother Hegarty left a gap in all our lives — it was not easy to get on with every-day living. The safe, strong sanctuary that had been held together by this gracious lady was now falling apart.

It was 1965 when Joe's father left the Mission to take up residence at Stradbroke Island. His brother Peter later joined the Army, Matthew married Grace Roma and took up residence in the family home. They were both very young. Carmen had already gone and was married to Tex

May Hegarty and her five sons — (from left) Bill and Joe, and in front Peter, Matthew and Peace, 1949.

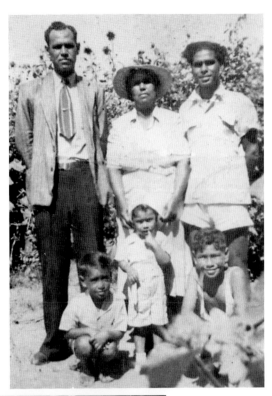

My Joe at 19, at his parent's house in Cherbourg, 1949.

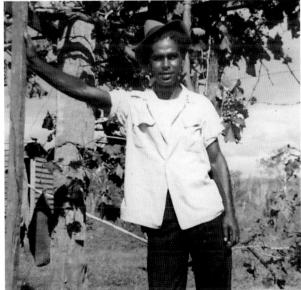

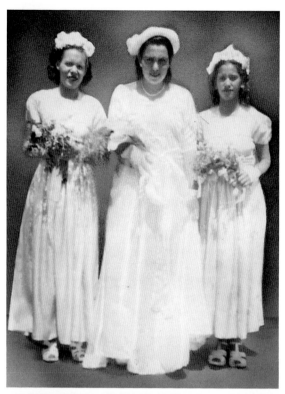

My dear friend Nelly Cobbo's wedding, with me (left) and Viola Button as bridesmaids, December 1951.

The Hegarty clan: (at the back) Iris, Mr Hegarty Snr holding Peter, Bill and Joe; (front) Norma, Mrs Hegarty with Peace, and Carmen, 1954.

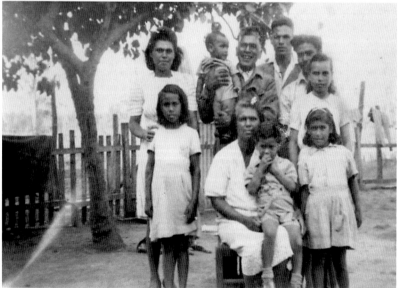

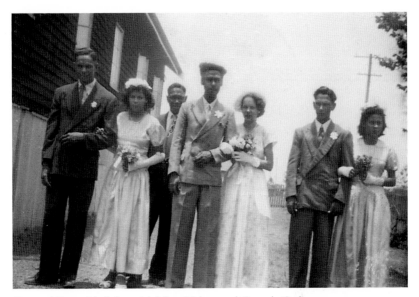

Our wedding, with (left to right) Len Malone and Gwenda Graham,
Uncle Eric Duncan, Joe and me, Joe Bradley and Pammy Bell, at the AIM Church,
Cherbourg, 15 December 1951.

More members of the Hegarty clan: (at the back) me with Norman (6 months),
Carmen, Merna with her son Paul, Matthew and Mrs Hegarty, and (in front)
Leslie (Merna's first son) and Glenys, November 1954.

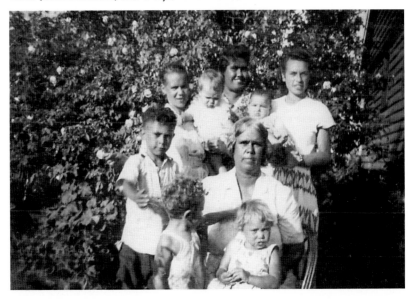

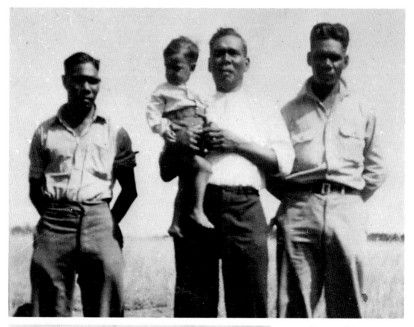

Some of the Duncan
men: Uncle Eric,
Grandfather Duncan
holding John, and
Uncle George, 1948.

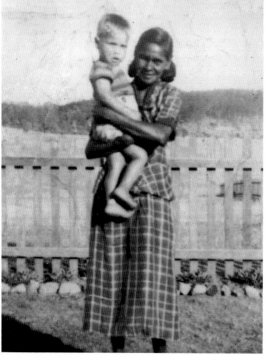

My dear friend and
helper, Jessie Wob,
with Manny at 2 years
of age, 1961.

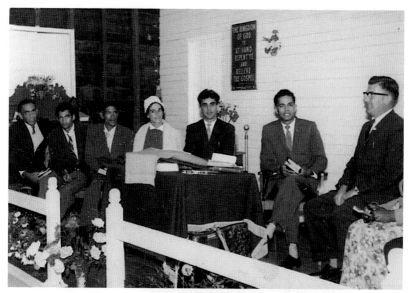

David Kirk's induction as pastor of the Cherbourg AIM Church. From left, Bobbie Hill, Norman Skeen (Treasurer), Arthur Bond Jnr, Dawn and David Kirk, Pastor Bill Bird, and Pastor Wesley Caddy who performed the induction, c1960.

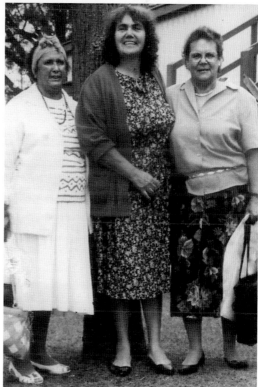

Together again at the Dormitory: Viola, Nelly and me, 1989.

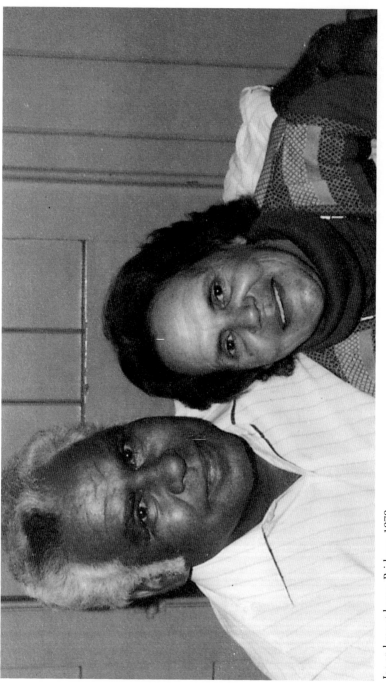

Joe and me at home, Brisbane, 1979.

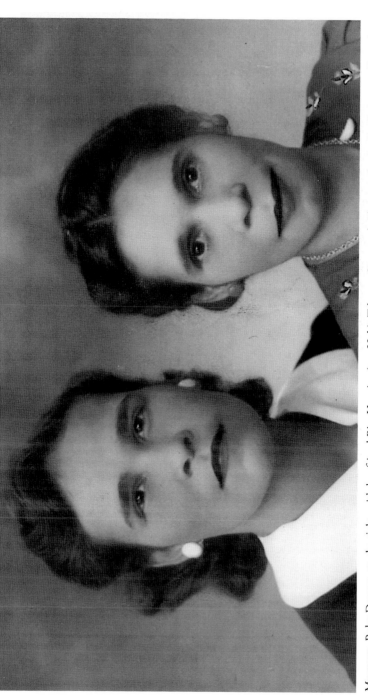

My mum, Ruby Duncan on the right, with her friend Rita Huggins (nee Holt). Taken at Simmonds Photography Studio, Indooroopilly, early 1940s.

Teaching the old ways — Joe with two of his grandsons, Duncan aged 11 and Thomas aged 13, and hunting dog Toby, 1982.

Ishmael Shibasaki and me on the wharf at Horn Island, December 2002. The first meeting since our Cherbourg school days, sixty years before.

Chapman, Norma married Les Wragge and lived not far from us. Every one of the family had either already left the Mission or were making their own history some other place. Nothing would be the same again. I called the house a sanctuary and that was what it was for me, but my mentor and friend was no longer there. By now all of our children were at school. Glenys was completing Grade Ten in Murgon and the others were attending the Mission school. Cassandra, my eldest daughter, had married Tom Creed at seventeen and had her first baby. I was a grandmother.

Joe's question, "What are we going to do?" started to have an impact on me. As soon as his Dad left I gave myself permission to begin thinking about our future. My answer to Joe was, "We move." This fell on deaf ears at the time but the seed was already planted.

Chapter 8
Journey Towards Faith

My life was changing also and, at thirty-seven, since the death of Marcia, I had become a Christian. I was attending the Aboriginal Inland Mission Church. The circumstances of Marcia's death pushed me into the loving arms of God. A young couple called Williams were our missionaries for a time. After they departed the Church membership was responsible for calling a new worker. It had always been envisaged that one day the Church would have an Aboriginal Pastor and become autonomous. It was 1961 when, at last, we saw the arrival of Pastor David Kirk, his wife and baby son. This was an historical occasion for the Church of just twelve people. I was not yet a member. Following the Church tradition I could not become a member until I was baptised. However I attended the Church business meetings, but without any authority to speak or vote.

Since 1928 white missionaries pioneered the work of giving spiritual direction and guidance at a time when conditions and treatment of Aboriginal people meant that they were little better than slaves. The missionaries brought hope in a hopeless situation when speaking out against harsh treatments or refusing to work could result in removal or suspended rations. Many of the older people found the missionaries helpful in teaching them to read and write, especially those who had not been to school. In keeping with the Christian faith, much of the old ways became less important as early Aboriginal Christians modelled their lives on those of the missionaries.

For about thirty-three years our Elders embraced the Christian teachings and held firmly to their beliefs and values. They became the teachers and, since the missionaries did not live on Cherbourg, they also became the role models that tested the victim status of those of us living on the reserve, that is: they found "freedom in Christ, a new way of living". They were the ones who were themselves victims of the controlling system they were forced to live under. The Church gave them purpose, a faith that led them to believe in themselves, they were empowered. The Church operated independently of the Mission rules, and Christians were deemed to be very upstanding and right-thinking people. Unfortunately, Church membership removed Aboriginal Christians from the importance of performing corroborees — the dances were considered

evil by the missionaries. Many will blame the Church for their intrusion that caused the loss of culture, language and dance.

Many of these pioneers were still in the Church when I took the Lord as my Saviour. They were all rejoicing. I was the rebel from the Dormitory, the one who threw away the Bible that was issued to us from the Church. At fourteen I was of the view that whatever I did was going to be done my way and not because someone else said so. However, after some failed romances, two babies and a marriage that led to violence and mayhem, I was seeking the help of God and His people to rescue me from the horrendous situation I was in. They prayed for me and Joe.

For some weeks after the departure of the previous missionaries, Mr and Mrs Walker, we were being ministered to on Sunday mornings by visiting speakers. A family called Venz from Kingaroy were regulars. The Sunday night services were taken by the local Elders of the Church. I offered to help with Sunday School, but again, in keeping with the members' rules, I wasn't allowed to help as I was not baptised. It wasn't that they didn't need me, it was just that they were dedicated to the teachings of the Church.

The members at this time included Mrs May Hegarty, Mrs Doris Brown who was Church secretary, Mrs Maud Phillips, Mrs Lilly Fogarty, Mr and Mrs Jack Demblyn, Mrs Thomas and Auntie Mabel Willis, to mention just a

few. After the departure of the Walkers these Elders had the responsibility to either deliver the programs themselves or call a new pastor. This was a new task that needed great faith and discussion so that we could all pull together. We kept in mind that the members had never had to find a pastor before. Missionaries came to us as directed by the Aboriginal Inland Mission so the call was an act of faith. The Church moved and acted as an independent body — this was not something the Church members could go to the Office about. The Elders were under guidance from a Higher Power.

Many names were put forward but none could take higher precedence than that of David Kirk. Born and bred in Cherbourg, a positive larrikin who was loved by everyone and had perhaps been destined for a trouble-filled life, David, along with his cousin Bill Bird, had changed direction and become Christian. This was followed by their enrolment in the AIM Bible College at Singleton in New South Wales. In the years following both boys served as missionaries (or Native Workers, as they were called), both had married and were keen to pastor a church.

The Cherbourg Church members called David and Dawn Kirk and were delighted that they accepted. We welcomed them with joy, they were young and eager to begin work. The Church membership took a giant leap from twelve to more than forty, with young and old working together in the sure and certain hope that our lives

would encourage others to a new life in Christ. The Aboriginal Inland Mission Church became the People's Church, and for the first time its membership knew what this involved. In the early 1960s wages paid to Aboriginal workers were very low and no pensions were paid, so an autonomous Church would challenge us all. In the past the missionaries had lived and worked by faith. By calling David we had put ourselves into a position of being responsible for the upkeep of the property and for the Pastor's stipend. The members of the Church supported the Pastor by contributing a portion of their very small wage each week. This was a real challenge to our people as in the past missionaries were not paid wages. Theirs was a faith mission — dependent on the good will of supporters.

David proved to be a good leader and we were a willing congregation. I was among the first group of eight people to be baptised. I was glad the baptism took place in the Murgon Baptist Church and not, as usual, in the creek at the Mission. David broke with tradition, however it was the middle of winter and the water in the creek was at its lowest level, all weeded over and probably full of leeches. I was happy! Baptism gave me membership of the Church and with it I was able to get involved in the Church ministry. The words that are used to describe the worth of people these days were foreign to us in 1961. I witnessed a growing Church — in spite of the obvious difficulties, of

Aboriginal people being portrayed as loafers and drones, living under the threat of removal and punishment, and being subjected to the control the Government had over our lives. The Church with the Kirks as leaders gave us a clearer understanding of our own worth and we were empowered by the spirit of God. There was never a shortage of willing helpers to take up positions, and so the Church grew.

The age groups ranged from teens to Elders with everyone contributing according to their gifts. When it is taken into account that the basic education provided at the Mission by the Government included only reading, writing and arithmetic, we — understandably — gathered in the Church with a hunger to study the Word of God. For the next four years David and Dawn led us, and through their preaching and teaching we began to believe in ourselves. Business meetings saw us actively involved in the life of the Church and, remarkably, we triumphed over what was considered an impossible situation. The belief that we were inferior to whites and that we could not manage our own lives was accepted by Government.

A young convert, Norman Skeen, took on the position of elected Treasurer. It was not common practice at that time for an Aboriginal person to be doing any sort of business in the Commonwealth Bank in Murgon. On sight they would be viewed with suspicion so, when Norman presented the previous day's free will offering with a

deposit book, the teller immediately left the counter and came back with the manager. Questions were asked, Norman was requested to identify himself and to give an explanation of why he was doing the banking, and not the missionaries. A phone call had already been put through to the Mission house and Pastor Kirk was on his way up to the bank.

David often spoke about "getting your gooly up" when your temperature is rising. He was angry, but the early 1960s weren't a good time for the Aboriginal people to be publicly doing business in Murgon. The public toilets still had signs "For Whites Only" posted on them. And since it was common knowledge that we, the residents of Cherbourg, were under the control of the Government Protector, what was this man doing banking money? After a discreet call to the Mission house to report that a native was in possession of the Church's banking, it must have come as a great surprise to the manager to discover that our Pastor was also an Aborigine. After some discussion our treasurer had no more trouble. In fact, he and David transferred the account to another bank in Murgon and even today the account has not returned to the Commonwealth Bank.

During the Kirks' four-year term the energy and drive displayed by both David and Dawn energised us all. We began to believe that a greater power was at work and it affected our lives in many ways. For me it was knowing that

I had the capacity to recapture those gifts I knew I had. As a child I'd always known that whatever I set my mind to do I could achieve — it really didn't matter to me that adults called me a show-off — I could sing, dance, mime, recite poetry, read aloud. I'd set most of that aside after I got married. I began small Saturday night concerts at our home for our children, who loved to perform too. We all benefited, being part of the Church team meant that we would be able to study as teachers, leaders and singers. Most of us had little education beyond the compulsory Fourth Grade, so how else would we ever advance our knowledge, even if what we studied was the Bible? However, while still under the auspices of the AIM, the Aboriginal student or assistant was still called the Native Worker. David broke out of the mould and encouraged each of us to look into our hearts and discover our own gifts with a willingness to use them to serve others. David Kirk pioneered work that may have seemed impossible. However, the People's Church is still operating today. With the help of some brave and forthright men and women a process was set in motion to give autonomy to the members.

So now I was teaching Sunday School, Religious Instruction and Christian Endeavour. None of what I was doing in my new-found life caused friction in our marriage as long as I did not question what Joe was up to. My night meetings, except for special occasions, were ques-

tioned, but I knew the rules and timeframes and to keep the peace I never strayed out of them. For me all this learning was enlightenment. I realised that I had gleaned so much knowledge and it led me to reading and studying the Scriptures in depth. I was on a high — not that it was visible externally — but it was what was going on inside me. It was that other me that was so carefully guarded. From Scripture I learned that "pride goes before a fall". I didn't dare let Joe see this inner me. When conflict and arguments occurred the violence I suffered hurt less. I was unable to talk to anyone about it but the reality to me was, "Whatever you do to the outside, you can't touch what is inside."

With the leadership of the Kirks we realised our potential and readily undertook roles and responsibilities that would otherwise not be entrusted to Aboriginal people. The People's Church, as its name implies, was the one place that was free from the prying eyes of Government officials.

Chapter 9
The Road to Brisbane

Four years after his call to the AIM Church at Cherbourg David announced that he had accepted a position as Vice-Principal of the Bible College at Singleton. The membership experienced a great sense of loss. I don't think any of us begrudged him the position, after all he and Dawn were graduates of the College. It would be wrong of us to do so. We would have all liked to follow the Kirks, but that was not possible.

My concern, however, was the loss of two friends who managed to extract from me the hidden skills of teaching and leadership. From them I learned a new way of dealing with the hurts and disappointments. David and Dawn were both natural leaders and together they possessed not only the ability to work as a team but also were able to perform as individuals. Our Church was all the richer and more motivated by their presence. I was devastated at

their leaving as again it was brought home to me that as long as I lived here in the Mission I would be bound to fear, control and harm. I wanted my marriage to proceed beyond the stage it was at, but how was I going to do it? I could expect no help from Joe, however the opportunity that I needed came from unexpected quarters. Was this fate?

Glenys, Pheonia, Mayleah, Moira, and Norman were selected to participate in the Harold Blair Holiday Scheme. We had never allowed the children to venture too far from home to play, but we encouraged them to bring friends to our house to play. So when the offer came for the Harold Blair Christmas holiday I readily accepted but was surprised, for neither of us had considered putting their names forward. What was out of the ordinary was that Joe also agreed to let them go. It was a chance then for Joe and me to have some time alone and, what was even better, my Mum invited us to visit her in Brisbane for a Christmas break. We accepted since five of the kids were off on holidays, so there would just be us and Duncan and Manny.

This was round 1965 and the two weeks turned out to be the most wonderful time we'd had for a long time. We took the boys to the beach, ate out at cafes and just enjoyed ourselves. Being free from the constant conflicts and arguments turned us into different people. It was two weeks of bliss and even Joe's few drinks with the boys

could not put a damper on our new-found happiness. I wanted it to last forever, I would have loved to have stayed in Brisbane. I had many reasons to believe that it could happen, however we could not avoid returning home to Cherbourg. We were going back to the same old life — unless I did something about it. I was determined we would leave Cherbourg.

Joe returned to work and the children came back from holidays and returned to school. They were excited and wanted nothing better than to share with their mates all that had taken place during their holidays, but this left me in a state of discontent. I wasn't at all happy, feeling alone and afraid for my future. I was concerned that I might lapse back into who I was before the holiday. Joe and I had both experienced a new way of living without all the senseless, irrational madness that we had been going through for years. I didn't want to go back to all that! We'd experienced the sort of happiness I'd longed for — a fortnight was not enough. We were all affected, in some way, by going away from Cherbourg for those two weeks.

Television was all the kids could talk about and they eventually persuaded us to buy a black-and-white television set. On a visit to Carmen and Tex we discovered that we could get a television set on a hire purchase deal. For the very first time in our lives we entered into a contract, not expecting the payments to bring so much stress. It was not hard for us to be persuaded to apply for a deal and, of

course, we were successful. Our house became the af-
ter-school place to go. Norman saw it as a way to make
money. He put a charge of three pennies on the kids as the
entry fee. While the TV became an enjoyable pastime I
was still stuck with the idea of leaving. Not even a tellie
would keep us rooted to Cherbourg! I knew that to sur-
vive and to achieve any sort of life we had to leave.

It was during those very critical times that the Govern-
ment sent a senior officer to the Mission to do a census of
the population of Cherbourg. The day he arrived at our
house was to change our whole lives — not that he knew
that! After he tallied up and recorded who lived in our
house, how old we all were, etcetera, I offered him a cup
of tea and he accepted. We talked about our children since
he had as large a family as ours. He was a very tall man
with bushy eyebrows, and as he sat on one of our kitchen
seats (built for small people) I couldn't help noticing how
awkward he must have felt with his knees almost touching
his chin. However I felt very comfortable yarning with
him. He said, "Do you mind if I ask you something?"

"No," I said, "ask away."

"Do you ever think about moving away from here?"

What a question! I thought — *I think about it all the
time.* I told him that I had, but I had no idea how I'd go
about it. He gave me some good advice, and even sug-
gested that if we decided to move we should visit the Bris-
bane office of the Department of Aboriginal Affairs as we

could be assisted in purchasing a home. Was this fate or what? I didn't believe it then, but looking back I believe I was being looked after.

I thought of nothing else but moving for weeks. How would I approach the subject, and how would Joe take it? From experience I knew this had to be a different approach — I was not planning on purchasing a washing machine or a refrigerator. This was much more serious. I was asking him to leave the Mission, his beloved home, and transfer to Brisbane. I wanted him to pull up his roots and go to a place that was strange and would take a lot of adjustments. I needed the right time, place and mood to bring up the subject. Often after tea we'd sit on the front steps at dusk and watch the kids as they played cricket. It was a neighbourhood thing (our kids owned the bats and balls) and sides would be picked. We had a small female dog named Biddy, an ugly little bitser that loved to play with the kids. She scouted for either side, went after the balls that were slogged too far down the gully and occasionally caught the ball in her mouth. Glenys, who was never happy with Biddy scouting for the opposition, would often tell her "You're not playing" if she fell victim to Biddy's ball-catching skills.

We sat that evening content to watch our children run, scream and argue. Joe loved to talk about the time he and his older brother Bill were given a set of wickets and bat, and when he was bowled out he would march off with his

half of the cricket gear. I may have laughed a little more that afternoon (I'd heard the story so many times) so that when it was time for the children to come inside and pre-pare for bed I was ready to make my move. I knew I would have to draw on strength of my "other" self, for that was where the courage and willpower was going to come from. I didn't realise that Joe was watching me and had been for some minutes.

I looked at him and he said, "What?"

He didn't have to say anything else. I was aware that he was really asking, "Is something wrong? What's going on in that head of yours?" It wasn't a threatening "what?", he was actually interested in what was going on in my head.

"I want us to move from here," I said.

He didn't say it but I was sure he was thinking, *Are you mad, woman?* The way he was looking at me I felt he was ready to talk about it.

"Why do you want us to leave?"

My reasons were clearly centred around the children, their future, their education and job possibilities. He wasn't saying no at this stage and that was good. "What about me, what am I supposed to do?"

"Find work."

However, it wasn't work that he was talking about, it was the hunting, fishing, his friends, and it was about iso-lating ourselves from what was our home.

"What about hunting and fishing?"

"You wouldn't have to give that up, you could come back on weekends."

We had nothing to hold us here any more. Since his mother's death, Joe's father and his other siblings but the youngest had left Cherbourg, and moving seemed the right thing to do. He got up to go inside and I didn't get an answer from him as he disappeared into the bedroom. I still remember calling out to him, "I'm going, I'll take the kids, then it's up to you."

My desire to go was greater than my fear of arguing with him. The moment had been seized and I was not going to let go, he might get angry but it didn't matter.

"Where are you going to live, you and the kids? You're mad!" he yelled.

I was ready with the answers, "You'll go ahead of us, get work and a house, and we'll follow."

I was surprised when he fell in with my plans so readily. My guess is that he knew I was serious about starting a new life and that I was sick and tired of constantly being on the defensive — or maybe, like me, he liked what we had experienced while on holidays.

However, as the plans to leave were being put into place I had some misgivings; I was concerned that Joe had not put up an argument. In fact, he agreed readily to go ahead and find work and a house. I wondered if he expected me to fail. I wondered if I was wrong for we would be plunging head-first into a world that we knew very little about

and maybe we would be confronted with racial prejudice. This was 1966 and we'd always lived under a cloud of racism. But the plan to leave had been put into place; we were selling anything that had any value so there was no turning back. Everyone knew we were leaving, going to the Big Smoke!

It happened much quicker than I dared to hope. Joe located to Brisbane with the help of Bowman and Edith Johnson. They had moved to the city many years earlier. Their home became a haven for many ex-Cherbourgites who were seeking work and accommodation. Members of their large family would often give up their beds to accommodate someone in need. With their help Joe was able to find work.

Even if our marriage had been perfect and we were the happiest people I believe I would still have persuaded Joe to leave Cherbourg. It was important that our children be given freedom to choose their own destiny and that the only limitations that would stop them from achieving their goals were those that they placed on themselves, not those imposed by mission life. Lots of changes were awaiting them — some good and some not so good. I was taking them away from a life that had caused only minor problems. However I was adamant that we'd get through whatever might threaten us, together. Teamwork was important for us to survive in the outside world. Selfishly, when I began the process of thinking I knew what was

best for us all, I was thinking of myself. Through the whole of the arrangements I regret now that I had not once asked the children how they would feel about going to live in the city. They watched as I put the plans into action, and even if I had consulted with them they may have agreed it would be good. However they may not have wanted to go. They may have been afraid to experience the many changes that awaited them.

At the Mission school they would never have undergone discrimination and would never have felt isolated and alone. Everyone at their old school knew and identified with each other. There was kinship, relationships and equality, and they would always have a feeling of safety and security. A neighbour would watch out for them if I was detained at the Hospital or the Store and was not there when they came home from school. I was determined and a mite selfish in making these arrangements to move.

I wasn't at all concerned at the time that I'd have problems with the children. Those two weeks away were enough to expel any of the fears that would have been there before the holidays. They were keen to continue a life away from the Mission. I had some misgivings that maybe I was taking our children away to a strange place and that they would blame me if it didn't work out. However, in recent talks on the matter, I learned that I'd had their full agreement from the beginning and that they'd

completely trusted me to do whatever was best for them and our future.

Joe's letters from Brisbane reassured us that we could begin our journey anytime so I lost no time in making our arrangements. We would follow his instructions. A letter arrived informing us that he had found a house and work and that he missed us. Bowman and Edith proved to be good friends, and with their connections Joe was able to rent a small house in Banyo and find work at Virginia Brickworks. It was enough to start us off. Three months was all we needed and, by the August holidays in 1966, we were ready to leave Cherbourg. With clever planning we would be at our new destination in order that the children could start at their new school after the holidays.

"Pack up only what you can fit into a small suitcase," I told the kids, "and include a mug, plate, spoon, knife and fork." Blankets, sheets and towels were packed separately — not that we owned much!

We sold the little we did own (the fridge, washing machine, our bed) and gave Jessie what she wanted. The money from the sale paid for our bus fare to Brisbane. We had a big send-off and lots of people were at the house to say goodbye. Most of our street came to wave us off and I felt a twinge of sadness, especially as I said goodbye to Jessie, Pansy, Auntie Queenie and Dick, and Uncle Len and Auntie May Duncan. It wasn't as though we wouldn't see them again, we were just changing course. A large gap

would be left in the community and they would miss us, I knew that. However, the die was cast and we were on our way. This was not just an adventure, this was our life and we would live it outside as best we could. As terrifying as it was for the children, it was just as terrifying for me. But I was not going to let them know my feelings as I needed them to trust me.

The trip down to Brisbane on the Service Bus was a long one and the kids were tired and hungry when we arrived. En route the bus stopped for a meal break but because we had little money we had to forego a big meal. Joe had arranged a taxi to meet us, we all crowded into what space there was. The taxi driver owned the house we were to live in. On arrival we got our first glimpse of our new home and Pheonia, the first one out of the taxi, yelled, "It's Green Acres!"

It was the smallest house in the street — one bedroom, sleepout, kitchen, lounge, bathroom (no plumbing) one big white tub, outside toilet and no laundry. Amazingly, there were no complaints and, mind you, there should have been! Joe arrived home from work to a great welcome. Small house, big family — but no regrets! Number 17 Hatfield Street, Banyo became our new address. We were plumb in the centre of the street with houses either side of us as well as opposite.

It didn't matter that back home at Cherbourg the house we lived in had three bedrooms and the outside complex

had a laundry, toilet and shower, the children accepted the outhouse, the bath without plumbing, and laundry. My children made me very proud as they said that we would face our difficulties together. We had a lot to learn and even more to get used to. The kitchen was so small that you could hardly swing a cat in it let alone fit six kids and two adults. I would regret leaving behind those prized possessions like the fridge and washing machine, but we would survive.

The kids were anxious to find the school and we discovered it was a fair walk across the railway line. We approached our first day with heads held high. We were all a little nervous, everything would be new. The five younger ones, Pheonia aged twelve, Mayleah eleven, Duncan ten, Moira nine and Manny seven, went to Nudgee State School and, as I enrolled them, I sensed how nervous they were. I'd brought them away from an all-Aboriginal school on a Mission and was now placing them in an all-white school. I was not going to make an issue of how they would feel or whether they would be accepted by the other kids. Discrimination had not yet entered their young lives and it was something they did not need to deal with yet. Being an Aborigine could become an issue, but they got a lecture from their father.

"No fighting, be proud!"

I saw them settled into their classes and I walked away from the school with the terrible feeling that I had de-

serted them. They were the most important people in my life and what I had done was for them. Then I walked Norman to high school. I really felt sorry for him. While the other five had each other, he was alone. I watched him as well, shoulders firm and straight, head high as he walked to his classroom. This was a new beginning. Pheonia, Mayleah and Duncan went into the same class as Duncan wouldn't be parted from them, unlike Norman he needed to stay in the company of his sisters.

When the kids arrived home from school I was delighted to hear that they had loved every minute of it. I was pleased that we'd leapt over our first hurdle! Lots of kids went to school from our street. Already a number of children in our street walked home with the girls, they had made friends. Norman settled in at Banyo High after a couple of scuffles. One thing Cherbourg did for them all was to prepare them to stand up for themselves.

Joe was happy with his job at Virginia Brickworks. He accepted the move without a word of warning like "If it doesn't work it's your fault". However, I had promised him that as soon as I could I would find work to help out with costs. I had no idea how I would do this.

We were so busy struggling to settle in and working to a budget that we had hardly noticed Christmas approaching. We advised the kids that we would not be able to afford much in the way of presents and a great feast, as we still had no furniture. Christmas would most likely be

spent eating on the floor in the lounge room, empty except for a foam rubber mattress. That would do until things improved. Eating Christmas dinner on the foam mattress was not a problem — I informed the children that we were having a Japanese Christmas.

A few weeks before Christmas and the beginning of school holidays, one of the most important things for me to do was to find a church. Advice from David, our pastor at Cherbourg, was to find a good Baptist Church. We found the Church after a good long walk quite some streets away, and we made our way there the next Sunday night. As we crept into the back pew many heads turned as we were late and the service halfway through. So when it was over our family of six kids and I were glad to leave. As soon as we were able, we were out the door. It took us a while to walk home, and waiting there for us was a family from the Church. They introduced themselves as John and Phyllis Sutherland and daughter Ruth. They lived only a street away.

"You were gone too quickly and we wanted to meet you," they said. We had not experienced such overwhelming friendliness from white people before this night. "Is there anything we can do to help?"

So began a wonderful friendship that lasted for many, many years. The Sutherlands were special people, their bond of friendship helped to empower us. Mrs Sutherland offered me some work cleaning her house and I was paid

each day. This helped us with keeping abreast of our everyday needs, as just feeding this mob was a strain on Joe's wages. To help our children understand just how difficult it could be at times we explained that now we would be responsible for such things as house rent, electricity, school fees, lunches, and a host of other things.

As Joe said, "There won't be any free issue."

When he brought home his first weekly wage (about forty dollars) we gathered the children around the kitchen table and they watched as we distributed the money into little piles for rent, food, etcetera. I wanted them to understand and to trust us as we were all in this struggle together, and as long as we did the right thing everything would be all right. I was desperately afraid of failing — our success and happiness depended on us being able to cope.

In the two years that we lived at Banyo we made many friends, our small house was always filled with the kids' friends from the street. It was at Banyo that I experienced my first visit to the hairdresser. I wanted to look good, what with Church and social activities in Women's Group. Even as I made the appointment I wondered if I was doing the right thing. I'd been raised to believe that we could not go into a salon because I was Black. We were living in the city now and my childhood seemed so long ago and so we behaved differently. We adopted new ways, much of the old ways were behind us. The "Whites Only"

notice on the Murgon Shire Council toilets was far behind us.

I was determined that I had to take the risk for if I didn't there would be no way forward. I waited on the street outside the hairdressing salon and out of fear I almost turned around and walked home. I'd forgotten I'd told Moira to meet me there after school until I heard her speak. This eight-year-old child spoke with such confidence. She and her brother Manny adapted to life outside the Mission with much more confidence than the other kids. Unafraid, and assuming that I had adapted as well as she had done, she called out as she crossed the street, "Haven't you gone in yet?"

With that she opened the door and in she went, sitting herself in one of the chairs. I couldn't let her see me in this state of nervousness so I walked in and was immediately greeted by the hairdresser.

"Now, what are we doing today?"

I was speechless.

"Mum's getting her hair permed!" Moira spoke up.

I was shown a chair and one of the girls began to work on the shampoo. It was almost as though I was a regular. I had taken a step. Little by little I began knocking down those barriers that kept me bound to the old beliefs that because I was Black I had to struggle for acceptance. The past and all its terrible events were just that — the past.

My permed hair met with full approval from the whole

family and it raised my self-esteem. Someone said, "Self-esteem determines success," but I didn't know it then. I began to face the demons that had imprisoned me for so long. Going to the fruit shop I made choosing my goods a real slow task, no longer afraid to select my own fruit and vegetables. I entered the grocery shop and browsed around before selecting. At the butcher's — even though I had no idea about weights and measures — I devised a plan that if I wanted meat for stew I'd ask the butcher how much did he think I would need to feed a family of eight. I grew in confidence and in doing so helped the children to overcome their fears.

Whatever their father and I did was for them. Things got even better when Pheonia was selected by the inter-school committee to play netball for Queensland. Mayleah played for the school netball team. The boys were into football and Moira was into everything. We were happiest when we shared with each other our daily activities. After weeks of living in an empty house we received some furniture from St Vincent de Paul, that gave us a lot more comfort. Although I was still washing by hand on a bench in the yard, we were doing well. We began with some small steps, and as the days turned into weeks and then into months we moved forward by leaps and bounds. Our fears were replaced with confidence even though we were struggling with our finances. The payments had to be made on the television, which we

agreed to keep for the sake of the children. We got used to paying our way as there was no one to borrow even a cup of sugar from.

Joe's words were, "If we haven't go it, go without!"

Chapter 10
Finding Our Feet

Going back home to Cherbourg to catch up on the life Joe left behind was not as easy as we thought it would be. Without transport it was almost impossible. For Joe, who was always in the thick of things, fishing and hunting were always a priority and I knew he missed it. However, he compromised by making spears for himself and the boys and they would go down to Cabbage Tree Creek to spear mullet. He didn't accuse me of taking him away from that part of his life and, in actual fact, he changed his priorities in order to teach his boys something of what he thought they had lost. He and the boys got very good with the spear so we ate lots of fish.

We were becoming aware, however, that with school, sport and out-of-school activities, we would never have enough money to support ourselves in our efforts to get ahead. I was always the financier in the home and it was

apparent to me that we were facing a crisis. I applied for work at the Cannery and, although the hours were long, the pay was good. I began work immediately and in spite of the hardship it was worthwhile in the long run. During the pineapple season I was earning enough to take the pressure off Joe. I was now very sure that what we had done was the right thing for we were moving forward, and it was clear to all of us that we would continue to do so. So far we had not experienced any setbacks. However, more money meant Joe could spend more time at the pub in Nundah and he began going into the city to drink with friends. I feared we would drift back into the bad habits we once had that could result in violence. I had little cause to be concerned. While at home at Cherbourg I'd had little or no support, here, with the Police Station just down the road, I believed help was readily available — though I never needed it.

We lived for two years in Hatfield Street, Banyo and in all that time put up with the inconveniences of not having a laundry. I faced whatever weather there was, washing out in the open. The bathroom had no pipes to drain water away and we were still using a bucket to catch the bath water. The landlord could not, or would not, do anything to improve our living standards. Mr Sutherland, our new friend and supporter, began talking to Joe and me about buying a home in Banyo. I hadn't thought of where the money would come from, however just thinking about

owning our own house was very exciting. Joe, the sceptic, began doubting it would ever happen but no matter what he said it did not dampen my enthusiasm. I worked with Mr Sutherland with goal setting. Joe argued that I drove him to drink, that I was never satisfied with what I had, and it brought on the violence again. But that didn't stop me.

I remembered the Department of Native Affairs had once made an offer to assist us to buy a home. It became my priority to remind them of their offer of a loan. I made an appointment to see whoever was in charge of properties. It turned out to be Mr Sturgess, our one-time Superintendent from Cherbourg. This was not good, as I had never had a good relationship with him up on the Mission. The old Mission feelings began to take over. However I went to the office determined to go ahead and I was calm, confident and in control. Almost as soon as I saw Mr Sturgess I thought of home — Cherbourg. For some time Joe and I had had control over our own lives, and now I had the confidence I needed to confront the people who used to have all the control.

You won't get help, Ruth, he's gonna tell you that owning a house is a pipedream. I refused to listen to my own negativity. I got myself ready, thinking that whatever happened I would not allow anything to get in the way. What happened next surprised the life out of me!

"Good morning, Ruth. Take a chair and tell me why you are here."

Was this Mr Sturgess? For a moment I had nothing to say. All I could think was I had been offered a chair by the ex-Superintendent, now how about that? Many times I had appeared before him at Cherbourg and his treatment was uncaring and unpleasant. I remembered that when confronting him you were left with a feeling of powerlessness as you stood and waited until he was ready for you. It was his way of deliberately treating you as a lesser person, victimising and controlling you.

"How is it that I am now seeing a different person?" I asked myself. Our conversation reflected on life on Cherbourg. It was as though we were old friends catching up on the good times. However, it wasn't long before we got to the reason I was in his office. I was aware I was taking a risk and that I could end up failing in my efforts to secure help from the Department. The first discussions took place around August 1967 and continued through to December of the same year, with our efforts to secure help from them shelved. As I mentioned, I was taking a risk but being afraid to do so hadn't even entered my thoughts. The first plan, to buy a house in Folgate Street, failed despite all the efforts we put into trying to persuade the Government to help.

Correspondence that has now come into my possession

suggests that we followed all the right procedures. In the last paragraph it is noted that:

> The home has been inspected and is a reasonable buy at the price quoted ($8000). The approval of the Hon Minister is therefore sought to make an advance of $700 to this family to enable the purchase of this house to proceed.

The correspondence and the approval were not made known to us. We were aware that the Geebung Rotary, of which Mr Sutherland was a member, was keen to sponsor us but everything came to a dead end. We tried other avenues that might be cheaper, older homes which might meet with approval. However the Department was not about to enter into any deal with a second-hand house. Our efforts to buy were all in vain. I then rang the OPAL Centre (this was the One People for Australia League) and asked for an application for their Improved Housing Scheme. As well, I made an application to Queensland Housing Commission around the end of October 1967. A house to rent from the Housing Commission became available eighteen months later. Often when someone wants to make changes in their lives some setbacks occur, but I would not allow this or any other hurdle to stop us from taking the next step.

Four bedrooms, a lounge, a kitchen with plenty of room, and an inside toilet and bath — 4 Wavey Street, Zillmere was the largest house we'd ever lived in. I can't go on without recalling our first night in the house. We had

enough furniture for two bedrooms, and a table and chairs for the kitchen. The three girls chose the large bedroom at the back of the house, sharing two beds. Joe and I had the front bedroom and the three boys decided to sleep in the lounge room. In the morning I walked out and found all six of them spread around on the lounge room floor. They said, "We were frightened to go to sleep — the house is too big."

It seemed that way only because most of the rooms were empty of furniture. However the luxury of an indoor bathroom and toilet was a real treat. The children had to go to a new school, but this time it wasn't such a big hassle. Although they would leave their friends behind they would make new ones. The lecture from Father wasn't new: "No fighting!"

It was the August school holidays that we moved to Zillmere so at the start of the new term I enrolled the kids at Zillmere North Primary State School. Pheonia and Mayleah were both in Year 7 and at the end of the school year would be heading to high school. Most of the Zillmere North kids were talking of Sandgate High and the girls felt it would be good to enrol there. Duncan and Moira were both in Year 6 and had another year to go before high school, and Manny was in Year 5. Norman went back to Banyo High for the last few weeks as he would graduate at the end of that year at Year Ten level. Norman was always very unhappy about leaving Cherbourg. At

thirteen years of age we'd asked a lot of him. As he reminded us, he left behind all his friends and a way of life that he was comfortable with.

I continued to work at the Northgate Cannery; my day started a lot earlier than Joe's and ended somewhat later. Banyo was a stone's throw from the factory where he worked. Joe organised the meals with the help of the girls, at night made sure homework was done and got the children up for school in the mornings. During the weekdays he was a model husband and father. These good times lasted for a while. We were now into our third year since the move from Cherbourg. We went back at times with Joe and visited, but we took to city and suburban life as though we had always lived there. However Joe still had a craving to go back, and part of his Christmas breaks were spent there. He purchased a second-hand station wagon. Glenys had left us and was leading a life of her own. Cassie, who had married Tom Creed, was still living on Cherbourg and we often visited her and the children.

Joe and I began to take an interest in the newspaper reports about the Referendum to be held in 1967. We had no idea that we were not citizens of this country and it's amazing that in all the years we lived on Cherbourg we were far removed from politics. Neither of us had ever voted and, in fact, most people that I knew voted only in State elections. You'd think we were living on another planet. So we enrolled immediately for both State and

Federal voting and became members of the Labor Party. It seemed the right thing to do. In fact, as each of our children reached the age of eighteen they registered to vote too.

A few weeks into the New Year of 1970 I began to think about giving up work at the Cannery and finding something nearer to home. It was important that I continued to work, our lifestyle had changed somewhat and we were living more comfortably. I'd talk to Joe about finding something closer. A new school meant more costs and then there was the house to furnish. Joe was earning, on average, forty dollars per week, my wage was seasonal and there were the monthly Child Endowment payments. One afternoon after work I got off the train at Nundah to go to the CES (employment) Office. Fate again intervened. It must have been the right day and the right time for me as I was interviewed and given a notice to go to Zillmere Road, Zillmere as they were looking for an office cleaner and tea lady. Margaret Collins, our good friend, drove me to the interview. I could be so lucky! My hours were 6.30 a.m. to 2.30 p.m., I would be paid weekly and the job was only twenty minutes walk from Wavey Street or I could catch a bus that left at 6.00 a.m. I walked home most days. For five-and-a half years I worked for Wilkes Printing, and we were a happier family ... for a while.

Over the past few years the whole family had shared the journey, the ups and downs, the disappointments. However these were not allowed to hold us back in our efforts to move forward. No negative talk, for we were well and truly grounded! Our children showed no outward signs of anxiety. It surprised me how quickly they'd taken to the life away from the Mission. No lectures were given in our house. The rules were set out and the children could choose to follow them or we all suffered. We were all so busy during those times — it was important the children get through primary school, and the girls were marvellous. They took on such a lot of the responsibilities in the home. Joe and I worked every weekday, and talk about a shared journey! Budgeting both wages was shared with the kids, it was important for them to know that we wanted to include them in everything. I loved my family and wanted only the best for them, unlike my own childhood: I had never had the freedom to truly discover myself. For them it was different. At the Dormitory we became victims of a Government policy that destroyed children's ability to have confidence in themselves so that we developed low self-esteem. That led to patterns of behaviour that were considered a good reason for punishment.

Our girls, Pheonia and Mayleah, were fourteen and thirteen years when they entered Sandgate High. I took them down to the school on the first day of the enrolment period and we looked at books, uniforms, the rules, and

the bus timetables. We were now able to access some funding from Abstudy (Government assistance for Indigenous students) and it helped to purchase what was required for school. However, the day before school began OPAL rang to tell me that Brisbane Girls Grammar School was offering a scholarship to one of our girls. I was thrilled to bits but the hard part was deciding which one.

Joe, very wisely, said, "Let the girls choose who will go."

A word of wisdom from Father was just what we needed. My mother was working at the Girls Grammar and was thrilled to bits. She had, for some years, been working as cook for the girls who boarded at the school. I always like to think that it was in honour of her the scholarship had been offered.

That evening we spoke to Mayleah and Pheonia saying that we needed to talk about it as the people at OPAL needed an answer soon. Mayleah chose not to go and that left the way open for Pheonia, who was not so academic but had great potential in softball and netball. She was a very competitive sportsperson and had already represented both school and State while in primary school. I was proud of them both, but I believed in letting them make the decision for themselves. They had been so close since we left Cherbourg, but were discovering their own independence and their own power. They remained, as always, the closest of friends. For the first time in their young lives they would be apart, but that was good as it

led them to discover other friends and their own potential.

The Aboriginal Hostels Ltd was advertising for trainee hostel managers. It had been a busy time since the 1967 referendum; the Government's recognition of Aboriginal people was beginning to take off. In the streets protest marches were being held as our people demonstrated for equal rights. We witnessed the setting up of numerous community-based organisations such as Legal Service, health service and accommodation services. Aboriginal Hostels Ltd was purchasing buildings all around Australia to accommodate students — male and female hostels. They needed to employ lots of people and they advertised to train Aborigines to become managers, bookkeepers, et-cetera. I saw this as a chance for Joe to try something different. The kids encouraged their father to apply for a trainee manager position. We had no doubt that he would win a position and that was all the encouragement he needed. We hoped that for the Hegartys it was onward and upward, all positive thinking!

Norman left home after completing Year 10 to do something he always wanted to do, and that was hitchhike around Australia. We were very concerned as he was only fifteen years of age. His keenness to go was brought on through having to live under his father's strict rules and heavy-handedness. On giving my approval I insisted he call home as often as possible, be careful and not take

chances. My prayer to God was that he would be kept safe, and I waited for his phone calls which came at regular intervals and gave me an account of where he was, how he got there and where he was going next. We were left with the two boys, Manny and Duncan, and the three girls, Pheonia, Mayleah and Moira.

Joe did get the trainee management position with Aboriginal Hostels Ltd. In 1973 Pheonia and Mayleah finished high school and then went on to do one year at Brisbane Business College. Like two fledglings they were getting ready to leave the nest, for they had reached that time when they were ready to make their own decisions. It seemed good to me but Father was not so keen to let them go. Many of our house rules were harshly put into place by him, one rule being that there was to be no dating until they were seventeen years of age. They had a strict timetable and if they went out with friends they were required to be home by 11.00 p.m. It was accepted that group outings were all right. Very often they would accompany big brother Norman to concerts. One, Credence Clearwater Revival, went so late. It was about the time of the great flood in Brisbane and I paced the floor wanting them to come home soon. Joe had arrived home from a party. He was drunk.

"Come to bed!" he yelled. I sneaked into the girls' room

and unlatched the window. They arrived home some time later, but nothing was said.

Duncan left school in Year 9 and his decision met with some opposition from his father and caused some arguments. Since education was our prime goal for the kids, the question was asked, "How come they won't stay at school?" While education was important so too was the freedom to choose which path to take. While the girls were finishing Year 10 Duncan was off somewhere finding his own way. My words, as with Norman, were: "Ring home and come home when you're able to" — our door was never shut to them.

Chapter 11
Koobara

The years preceding the Aboriginal Development Commission elections were busy ones. It was part of the Federal Government's promise of 1967 that Aboriginal and Islander people would have more say in determining the future spending of the funds that were available for better housing, health, legal services and education for Indigenous people. An election would be held nationally for a body called the Aboriginal Development Commission. Candidates were chosen from the different regions and those who were successful formed the ADC.

In keeping with a promise I had made to Joe that I would not get involved with the Black community, I continued on working at the Printers to help support our home. By now our family had become somewhat smaller, all but Manny had left home. Joe and I began to enjoy this period of our marriage. We were still renting from the

Queensland Housing Commission, the hopes of buying a home were permanently put off. Joe still aspired to going back to the Mission. That was his dream.

After five and a half years of working at Wilkes Printing without a care in the world, I received a bit of a surprise one afternoon when coming home from work. I was met by one of the young Aboriginal mothers who had recently moved into the suburb. It was Melita Orcher, I was glad to see her. Quite a number of Aboriginal families were being accommodated in Zillmere by either the Department of Aboriginal Affairs Home Scheme or the Queensland Housing Commission. The Brisbane floods of 1974 had left many homeless.

I listened to her story about discrimination in the way that children were selected to attend kindergarten. Since our family had never faced anything of this nature I wasn't sure I wanted to get involved. I heard her ask, "You think you could help us, Auntie? I could get the other women together to meet with you tomorrow afternoon?" As she asked the questions I looked heavenward, and as I did I wondered if our Heavenly Father was saying, "Your children are all educated, now it's time for you to involve yourself in the community." As I walked away I indicated that I'd see her tomorrow afternoon.

I didn't have to concern myself with anyone else's problems, our lives were travelling along really well. I thought, *Joe will put a stop to all this, I won't have to help.* I told him

Melita approached me and shared the concerns with him. What he said threw me: "You'd better help them, then."

I thought how ironic this was. I remembered praying to God at the beginning of our journey, that my only reason for leaving Cherbourg was to advance our children's education so their futures would be more secure than ours had been. I prayed that He allow me to do this however long it took, I asked for good health and a secure future. Even though I wasn't keen to get involved in missionary or community work I believed that God would be with me. Now only one child remained at home, he was completing high school at Sandgate High. Who else was there to educate? Now these mothers were trying to place their children in kindy for the same reasons I did those many years ago. I was not able to convince myself to ignore them.

I met the mothers the following afternoon. Dorothy, Maud, Molly, Inez, Erica, and Melita were all keen to talk about their experiences. "We can't get our children into kindergarten," they said. All the usual remarks were made, the accusations of discrimination against Black kids.

"Okay," I said. "What you lot want me to do?"

"Ring them up and have a go at them."

This was all so new to me. I was happily taking care of me and my family, I did not get involved with the protest marches that were taking place for equal rights. This was the early 1970s. Since 1966 the Hegartys had also been

striving for a better way of living and we made it through to 1976, and, I will say, without protesting.

I agreed to phone the kindergarten in question and come back to the women with an answer. It was not something they expected, there was no discrimination. However, the kindy organisers pointed out that they had a system of application for a child to enter kindy, and our parents could enrol but — since they had a waiting list — it would not be possible that the child would be taken in immediately.

"What can we do then?" they asked.

"You can enrol and wait."

Molly asked, "Could we have our own kindy?"

My dear friend, Jean Phillips, a missionary, entered into the discussion and suggested we approach the Crèche and Kindergarten people for advice. I was elected to do this job, since we had the telephone installed I would do the ring around. Weeks later a meeting was arranged with the Director of the Crèche and Kindergarten Association, Miss Peggy Bamff. She addressed the women and saw no reason why we could not set up an Aboriginal and Torres Strait Islander kindergarten. With this information in hand they elected me to spearhead the project.

Of course, I was still employed. Since we didn't need the second wage maybe I could, with Joe's blessing, give up work. My boss, Mr Whittaker, was taken aback when I handed him my resignation with two weeks notice. My

answer to his question of "Why?" was simply, "I'm going to help my People." I can still hear myself saying that as though it was yesterday.

"Who are your people?" he asked. I filled him in on all that I imagined I would be doing.

"Will you be paid?" he asked. The answer was "No."

I knew that this was my calling. I accepted it not realising how much would be involved in setting up our own Aboriginal and Islander kindergarten. A handful of Aboriginal women met, with the dream for their children's future that I had had all those years ago. Of course, it was challenging but we dismissed the thought that something of this nature — and, I would add, magnitude — was impossible.

We prayed to God before each meeting for wisdom and guidance, the whole project required knowledge. I had no small children who'd attend the proposed kindergarten but I remained within the group, absolutely infused with their enthusiasm. "We can do it" is what I saw on their faces. I was elected Chairperson at our first members' meeting, after which work commenced on the constitution. Young Sam Watson, a university student doing law, offered his services and it was through Sam's efforts that a constitution was drawn up and the kindergarten was formally named Koobara.

I remained its Chair for eleven-and-a-half years. In time we would establish our autonomy, by cutting ties with the

Crèche and Kindergarten Association of Queensland. Throughout those years we maintained the required number of children to retain the funding that was available. As children left the kindy to attend primary school we also lost the parents and as that happened new parents and children came on board.

Our name change and constitutional changes began with the promise of more funding if we became a Resource Centre and Kindergarten. The Committee approved the proposal for a Federal grant, since for a number of years we had moved several times from location to location, seeking a safe and secure base. The funding promise enabled us to rent premises in Zillmere. However, the Federal Government reneged on its promise just about the time our six-month lease on the property was finalised. Another move was on the cards and it seemed like there was no place available and no funds. The Committee went away to think about where to go next.

As I sat at the bus stop that day I felt defeated but I got into a conversation with a dear lady. She told me that the kindergarten that operated from the Uniting Church on Zillmere Road was relocating their program. Talk about miracles and an answer to prayer! Without contacting the Committee I phoned the Uniting Church property manager and expressed my interest in taking out a lease on the property, and gave him the reasons. The Committee duly

met with the Uniting Church members and we formally became the new lessees.

I saw opportunities that would enable us to become more than just a kindy.

The Federal Member for Lilley, Mrs Elaine Darling, took a keen interest in Koobara, visiting us on numerous occasions. She listened to our concerns and helped to secure a grant of $35,000 through the Commonwealth Employment Program to enable us to employ two home-helpers. Even before the Aged Care Programs and Home and Community Care Day Respite and Home Help began, Koobara was involved in providing home-help to the sick and aged as well as to young mums.

We secured funds to employ an administrator/bookkeeper and a social worker. Koobara Committee turned its attention to other issues; we set up a vegetable co-operative for families. They contributed money, and a visit to Rocklea markets once a fortnight provided fruit and vegetables. We provided advice on the healthy preparation of food. Funding was received from Queensland Council of Social Services in May 1984 to be used for emergency relief. Ms Jackie Huggins from the Department of Aboriginal Affairs was a valuable support person and adviser.

I was busily getting on with the work at the school and not only enjoying the work but also being able to witness the first group of Koobara Kindergarten kids enter into State school. This was an historic occasion that was a

credit to the good work of the Crèche and Kindergarten teachers and the Board of Directors, and especially to our young Aboriginal mums who initiated a program that has lasted for thirty years.

I had continued my work with Koobara as the Chairperson. Our committee, by this time, was looking for avenues that would make a change in our lives. Most had children going to kindergarten and had ample time on their hands. Craft was big back in those days, dressmaking, arts and craft of all sorts, and cooking.

"Let's choose what we want to do," I said.

It was Molly who suggested the Assertiveness Course.

"Why?" asked one woman.

"Well," she said, "have you ever sat on the bus and listened to white women talk to one another? They carry on conversations for the whole length of the journey."

"Yeah, and you can see they don't really know each other."

"Can we talk to a total stranger for that length of time?"

"We can learn how to," I said.

"How do we do that?"

"We'll do the Course on Assertiveness."

The Course was funded by the Education Department and we attended Bald Hills TAFE, one night a week for eight weeks. If I can recollect correctly, the number of women who attended was thirteen. We were all keen to take up any Adult Education courses that would help to

empower us. The whole kindergarten issue was now pre-
senting us with more than just daycare for the children.
Everyone realised that we had needs that must be met.
Our need to communicate orally was recognised as an im-
portant one, so we were moving beyond the basic needs of
the children to include ourselves.

On our first night we didn't know what to expect and
we talked and laughed in the bus with excited anticipa-
tion. Almost like kids going back to school we entered the
room and sat quietly like obedient children in a semi-cir-
cle. Our teacher walked in and introduced herself. We
were amazed that our teacher had an accent and could be
Greek or anything different to teachers we had known, so
it meant listening more intently. Our introduction to
Assertiveness, on that first night, was enough to excite us
to continue with the scheduled classes. We discovered that
what we, as Aboriginal women, were learning would help
us all in the art of speaking and doing it in a more appro-
priate manner. For example, we'd be likely to say:

"How you?"

"Good."

"How the children?"

"Yeah, alright."

Instead we would learn the "proper" way. We could say,
"Good morning and how are you today?"

"I'm very well, thank you."

"I do like the dress you're wearing. It's a pretty blue. It suits you."

"Thank you, I don't always wear blue, however I bought it at a Myers Sale."

Every week our conversations were sounding more and more like we were enjoying stringing those words together. Role play was an hilarious time as we were required to compliment each other. I don't think any of us had ever done anything like that, face to face. Since it was role playing it was easy to play the part. However, on a more serious note, we actually enjoyed paying compliments to each other and taking an active role in decision making.

We were never short of courses to choose from, courses that would build our self-esteem and enrich our lives. Just as one course was finishing we would be preparing for another.

So we began with craft, and the Education Department supplied funds for the teacher and for the craft items. Once a week we met, and when one series of lessons finished we started another. We enjoyed such crafts as macrame, screen printing, cottage crafts and patchwork, then we advanced to things like dressmaking and cooking healthy food. We agreed that if we had a street stall our craft would have to be good enough to sell. And sell we did! We made cakes, jams and anything else that would sell. Our street stalls were successful and then we had to decide how the money would be spent.

Parenting was another course the Koobara mums wanted to pursue. The STEP Program for Effective Parenting was indeed popular in motivating us to be better parents. In looking back I recall the involvement of many people whose career paths, at one stage, included Koobara as a testing ground towards bigger and better things.

My resignation as Chairperson from Koobara after eleven years, and following the death of Joe, was laden with deep sorrow, but it was time to move forward and allow a new challenge for someone else. I can look back with great satisfaction and my memories are filled with many people who helped establish a worthwhile organisation that is still operating successfully today. Its foundation was built on the strength and integrity of women whose dream it was to establish and organise a kindergarten where their children would not be denied a right of way that should be available to all Australia's little ones.

Chapter 12
New Challenges

I had no small children going to kindergarten and at the end of a busy year I was anxious to go back to work. Everything that we began to do had been done. However I needed something new to fill the hours. We finalised setting up the Kindergarten so I was no longer needed. My role as Chairperson was required only for monthly meetings. The staff were competent enough and worked by the Crèche and Kindergarten Association's standard rules. The question that arose in my mind was, "What am I going to do?" There's no feeling like not being wanted and I needed to go back to work. I ran it by Joe and, as always, I thought he'd come up with something. It could be, "What are you wanting to go back to work for?" However, he surprised me once again by saying that it was a good idea if that was what I wanted. "But please," he said, "don't go back to cleaning."

"I'll pray about it," I said.

While sitting meditating a thought came to me. Some months earlier my friend Jean Phillips, whose resourcefulness had led her to contact me, thought I might be interested in a position she'd heard was available at Zillmere State School. They were looking for an Indigenous Teacher Aide. I was not even aware of what that meant. *Jean must have mentioned that over a year ago*, I thought. At that time I was not at all interested as the job was casual and I'd needed to be employed full-time, but the situation had changed. I had resigned from the cleaner's job that I had been working in for so long, and even if the new job wasn't available I was after a change. Our finances were pretty balanced but that was not the reason I wanted to go back to work. I wanted that busyness I had become used to. Sitting at home was driving me crazy so I took a chance. I asked if I might place my name with them — just in case. The secretary was surprised that I had rung since the position had been vacant for some months. She asked if I could come in for an interview the next day.

"Good news!" I called out to Joe as he came through the door that night. "I've got an interview tomorrow morning for the teacher aide job at Zillmere South."

As he sat down on the kitchen chair I saw the smile and the head shaking from side to side. I didn't like the shake of the head.

"What?" I said.

"Nothing," he replied.

"That's not true."

Still shaking his head he smiled as he finished rolling his cigarette.

My mind went back to when we were twelve years old and taking part in the Sunday School play. The play was based on the children's hymn "Will There Be any Stars in My Crown?" Joe wore the crown and I teased him terribly about his head being too big and said that if there were any more stars on it, the crown would fall off his head. At school we used to get stars for good deeds. In one of our arguments many years later, during the early years of our marriage, he accused me of being too good for this world and he said that he'd like to get a glimpse of me in Heaven, "Your crown will be so heavy with stars you'll have a crick in your neck trying to hold your head upright."

In his own way I believe he was proud of me. I was daring and not afraid to try new things, even to the extent of stepping a little further out into the deep. The small steps I had taken since leaving Cherbourg had gotten me to where I was now. Setting up the kindergarten was behind me, but that wasn't a solo effort, I had many others to share that work. Here, the deep I speak of is me alone, there was not that safety net of other people. I was in it and it was sink or swim. I wondered if, with what was

happening and the many blessings we were receiving, Joe might have been thinking of the rewards being "stars".

I arrived for the interview on time and sat waiting for what seemed like hours. As the headmaster, Mr Cole, greeted me I tried to put on my most confident act while all along my insides were shaking like jelly. When asked what I could contribute to the job I confessed that I had no academic qualities.

"However," I said, "if you want to reach out to Aboriginal parents and children I'd be the best person to do that on behalf of the school." I told him about my community involvement, about Koobara Kindergarten and our hopes and dreams for a new generation of children who would do their parents proud. I knew the community. I was the only applicant and was immediately given the job, so another phase of our journey was about to begin.

I arrived for work at 8.00 a.m. and was immediately taken to the section of the school that housed Grades One, Two and Three. I was terrified! I had not been this close to a school since I was fourteen years old. As a child I attended the Cherbourg State Primary School, a school for Aboriginal children on the Mission. The school was overcrowded and we were taught in three classrooms and even spilled out onto the veranda. Two classes were seated in each room with one teacher in attendance and what is now

called a teacher aide, then called a monitor. Over sixty children were in a class.

I went to school when I was four-and-a-half years old and left at fourteen, in that time we advanced only to Year Four. It was at that stage that many young girls were taken out of school to be sent away to work. School did not frighten me, I guess it was the changes and my advancing years that led to my nervousness. I felt out of my depth, expecting to be treated differently as the Aboriginal people were still going through the process of being accepted in the community, still seeking equal rights and recognition. I also felt guilty as I had no qualifications and I wondered if all the teachers knew! However everyone made me feel welcome, especially the Headmaster, who was so very supportive, and that helped considerably. This was the beginning of an era for me to come out of the box, a time to stop thinking of myself as valueless and not being able to contribute. When Joe said, "Don't go back to cleaning" it was indeed, for me, a huge step forward.

I was assigned to Pat, the Grade 1–2 teacher. She was so pleasant. She shared with me her concerns for the Aboriginal children entering Grade One. Her concerns, in fact, were the same as those that were the driving force behind Koobara Kindy. Our mums were also mindful that any pre-school activities, be they kindy or pre-school, would make school an easier and happier transition for their children. Pat and I both would look

forward to the first intake of Aboriginal children from Koobara the following school year.

Very few Aboriginal children sat in the classroom that first day, but I knew that was going to change and it was our Aboriginal Kindergarten that would do it. I was informed that because there was no preparatory work in the lives of our young children entering school for the first time it created a lot of problems in behaviour; for example, they had trouble sitting still in class or following the very basic rules. It caused a lot of frustration all round with parents not always able to face up to parent–teacher interviews on behalf of their children. Often there were other small children at home and transport was difficult.

I was quietly confident that the next intake of our kids at Zillmere State Primary School would not only be prepared for that next step but would be anxious to start — and it happened just as I thought it would. For the following three-and-a-half years I enjoyed my role as a teacher aide, pleased with myself and with the skills that I developed. These were simple things like making up charts, reading to the class — it reminded me of the times in the Dormitory when I enjoyed reading aloud to the other kids — and taking over when the class teacher left the room. For the first few months I had a mortal fear of those small faces that were directed towards me. However, as time moved on, all that changed.

A year before I resigned from my position as teacher

aide I was encouraged by our northside community to become a candidate in the 1977 National Aboriginal Conference elections. I was meeting more of our Aboriginal parents and chatting with them in the shopping centres. Joe was my greatest supporter but enjoyed being on the edge, not in the centre of it. Unlike him I had extended my comfort zone and had lost the fear that, at one time, had a firm grip on me. I was not aware of the work that was involved in campaigning. What was uppermost in my mind was what it would mean for northside Brisbane to have a successful candidate. It was very clear that the northside was neglected and, as more and more families were making their homes in Zillmere and surrounding areas, the need for housing was high priority. Joe travelled all the way with me during those elections but, after losing by one vote, I didn't think I would do it again. However I did, though Joe wasn't there to cheer me on the second time. Eleven years after his death I again put my name up to run, I was then sixty-seven years of age. This was for ATSIC, the Aboriginal and Torres Strait Islander Commission, and again I was not successful.

Chapter 13
Full House — Again!

My life and, indeed, my interests were now moving along at a rapid pace. I knew I had Joe's permission and that he was proud of me. Joe's approval meant a lot to me, I valued his support. I no longer lived in fear of him, the violence had by now subsided. His drinking was not a serious issue. I guess I knew how to handle it.

I had not won a place in the elections but life goes on — only not always in the way we want it to, as Joe and I realised when we discovered that four of our grandchildren had been placed in Warilda Children's Home. I was surprised to hear, by accident, that the children were in the Home waiting for placement. Through previous interviews with a Family Services Worker we were aware that Glenys, our daughter, was going through a rough patch. She had chosen to live some distance from us and because of that we were not able to give her a lot of help.

Being a single parent living alone with four children pushed her over the edge. She was seeking a break from the stress she was under and, as we discovered, the children were placed there to give her some time to sort herself out. At the same time life for Joe and me was almost perfect. We had, for years, adjusted our lives to suit each other. It was a sort of give and take, and I'd do anything to strike a balance.

Although I was not happy with Joe's drinking, it wasn't an everyday thing, but when he did drink it was from Friday afternoon to Sunday as though he had no control. His violent nature would appear at those times, but instead of sticking around I'd leave the house until he went to sleep. Afterwards he would display a great deal of displeasure and aggravation at his reaction to the drinking and its consequences, and would show remorse by having a dry weekend when we'd go to movies in the city together or to the fights or wrestling. These were precious times, but they did not occur often enough. I'd get a glimpse of the old romance we enjoyed like holding hands and kissing in the movies!

With the news of the grandkids it was Joe who made plans for us to go and see them. I could see the writing on the wall and I was not happy. I was angry with myself and had to pray to God. I did not like what I had going through my mind. I was in my fifties and for the first time I was comfortable with my life as it was and had no room

to raise any more children. Our other children were happily living their own lives. We were enjoying visits from their children so most of the hard yards were behind us. Joe's father, Grandpop (as the children called him), had been living with us for a number of years. I guess I could say we were very comfortable.

The visit to Warilda was to change all that. Merina Jo, the eldest of the four, had often spent the weekends with us and was a favourite of all her aunts and uncles. Her Pa lovingly called her Mini Jo. With just one look at our little people, I knew Joe and I would not leave them there. Mini Jo, Wayne, Duncan and Matthew — seven, six, five and four years old — were waiting on the lawn for our visit. They were so clean and tidy and their little faces lit up when they saw us. To the two smaller ones we were not so well known, and Wayne, not one for fussing, stood back. But Mini Jo raced into her Pa's arms, happy that we'd come to see them. Immediately I put aside my own selfish feelings, for these children were ours and I could not help thinking of that part of my own life that I spent in the Dormitory, and I did not want the same for our grandchildren. We immediately made plans to set up a meeting with the Children's Services officials and Glenys, with the outcome being that we would take the two older children and the two younger ones would go and live with my cousin Robbie. She and her husband had no children. It was an arrangement that would be in place until we

sorted out our own living arrangements and work commitments. I resigned from work at the school not long after taking the children. Mayleah, my second-youngest daughter, became my replacement. She and her husband Steve were living in Caboolture and we became the babysitters for her three children while she was at work.

What had been, just a few months ago, a quiet and almost empty house was now almost bursting at the seams as all our living arrangements had been finalised. The two children left with my cousin Robbie were now living with us too. Amazingly, Joe and I had gone the whole cycle, we were back to where we had begun. I was in the midst of huge piles of washing, ironing, cooking, cleaning and school visits, so there was never much time for leisure or pleasure. Glenys was given an ultimatum — we would take the kids but she had to take charge of her life. We'd be their grandparents and would not ever take away from her rights as their parent. We had a lot of adjustments to make and make them we did. This was just another phase of our journey.

Carmen, my sister-in-law and wonderful friend from Cherbourg days, became my greatest support during those times and did I need it! She and Tex and their family moved back into the area from Roma, and it was good to have someone to relieve the load of stress. Our families had been separated from each other for a long time. We'd sometimes paid them a visit out at Roma but it was not

the same. Joe loved having his baby sister back as she was the image of his mother and possessed all the same attributes of character and nature that I would ascribe to his mother. They both had a love of fishing and that pleased Joe.

Chapter 14
Joe's Dream

Joe's dream began to form, funnily enough, when he arranged an Easter weekend at the Brisbane River. "These kids have got to learn about the bush," he said.

And so began our yearly trek to the Brisbane River, which went on for a number of years. These camps began to raise Joe's self-esteem. He was in his element. He assumed the position of leader and teacher of the bush ways to his grannies (grandchildren), and nephews and nieces. In spite of the cold weather the children found time to swim in the gently flowing stream of the Brisbane River. Our numbers grew (most of our extended families came along too) until our campsite resembled a sort of tent city. One huge tent housed all of the children as well as a few adults, and cooking for this great crowd — often thirty or more — was a real chore. It was back to bush tucker and fish. We have

lots of photos and slides as solid proof of some wonderful times.

This was the 1970s. With the on-going push by Aborigines for equal rights, self-determination, self-management and land rights we felt the fallout. Our camp became a threat to farmers and graziers. We had to seek permission to fish and hunt with dogs, and our rifles gave some concern to stock owners. Our excursions were restricted and our activities just about paralysed. We were forced to become trespassers, with all hunting done by the adults sneaking around. This defeated our main purpose of teaching culture to our children, as they were forced to remain in camp. We were warned by the landowners about campfires and the danger of bush fires. This was an insult to Joe and to the other kinfolk who joined us. They were responsible men who, for years, had been taught the ways of the bush and its preservation, and this was exactly what they were teaching the children. It certainly put a damper on the continuation of our camps. The menfolk who came camping didn't think it was worthwhile going to the Authorities. The lives of these men had been lived under such oppression they were truly dominated by Authority. Around 1977 farmers' concerns were matters of politics due to Native Title and protests regarding land rights.

During one of the first NAIDOC celebrations (that's the National Aborigines and Islanders Day Observance

Committee) Joe challenged a newspaper article that said Aboriginal culture was dead. This resulted in Joe being interviewed. "Joe teaches 'old ways' of the bush" was the headline of the interview that was published by a reporter from the *Courier-Mail*. While it was not written as a direct result of the threat to camping, Joe used the interview to highlight some of his concerns. He talked about keeping alive the old ways, passing on his knowledge to his grandchildren, and he told the reporter that his bush excursions depended on permission from property owners. He also disclosed his dream: "that one day an area of land might be set aside so that young children, both black and white, could be taught the old ways." We were proud of his interview. Not often a man to speak out, Joe used the opportunity to assert his rights and voice his concerns.

Joe's "old ways", his dream of passing on his heritage and teaching the children, were reduced to just one night of fishing and hunting on the weekend. Often he and I would join up with Carmen and Tex and spend a night on the creek. We observed the "no fires" rule and when it was cold Carmen and I would wrap ourselves up with many coats to keep warm. Fishing was conducted in the dark. Little bells, often taken from babies' slippers, or a bit of white material, were tied onto the hand lines. That would alert us in the dark if a fish nibbled on the bait. We'd fish until Joe returned from a hunt and then make our way home. Cars became our means of transport then — the

days of riding horses, for us, were long gone. The children were content to spend a whole day at Lake Kurwongbah fishing and swimming in keeping with the old ways. To the grandchildren their Pa was a hero, and even though many years have gone by they still speak of him with pride, and love to tell stories of their involvement with him. One such story goes like this:

"Hey Pa, did you know that I was part of an Aboriginal?"

Young Steven, Mayleah and Steve's eldest, sitting on our back porch in Wavey Street, Zillmere asked the question.

"Yes, Son," Joe replied.

"How did you know that, Pa?"

"Well Son, I'm Aborigine and your mother is my daughter, you're her son so you're a part of me."

The nine-year-old looked at his Pa with pride and simply said, "Wow!" Pa wasn't going to let the conversation remain there so he asked, "Steven, who told you that you were part of an Aborigine?"

"My teacher. She said, 'Steven will be able to talk to us about eating wild game because he's part Aboriginal'."

Joe had always maintained the belief that, since six out of eight of our children had gone into mixed relationships, their parents should be the ones to tell the children about their Aboriginal heritage. He ruled out that we should be the ones to inform the grandchildren of their

Aboriginality, and insisted that it should be the parents' right to choose the best time. In the meantime the children were interacting with us almost on a daily basis and being taught the "old ways" by the best bushman in the whole world, eating bush tucker and generally being Aborigines without knowing it. Joe felt it could cause problems for the parents if we took on the role of telling the children about their background, and he often said there was a time for everything. His dream was in danger of being lost to misinformation and scaremongering that was taking place during the Native Title protests. However, many years later his dream became a reality, and I will go into that in a later chapter.

Chapter 15
Loving and Loss

In June 1981 we suffered a heartbreaking loss when Wayne was killed in a tragic accident on his way home from school. We heard the ambulance go past the house about the time he was due — he was always home at the same time. As I ran out into the street I could see other mothers gathering at the scene, and I prayed that it was not one of mine.

Though we planned a small funeral, just for the family, we arrived at the church to find it packed, with those who couldn't get in gathered outside. In his short life Wayne's friendliness and warmth had touched so many other people. He was only twelve, and coping with his death was very hard for all of us.

Loving and being loved is what makes life the best and, as we grew older, there was a mellowing of my husband. We developed a relationship that had been tempered with

time. Joe's father, Joe Senior, had been living with us for a few years and this may have contributed to the peaceful situation in our house. Grandpop (as the children called him) had his own circle of friends and was loved and respected by all who knew him. He was a very refined and handsome man who loved to sing and play the mouth organ. He lived with us on and off for ten years but moved in permanently during his last four years. He loved to celebrate his birthdays and we had a great party for him on both his seventieth and eightieth.

It was his seventieth that was most memorable for me. We hired the OPAL building for the celebrations and lots of family were invited. We danced and sang and ate and had a jolly good time. That day a cousin of Joe's decided to play a joke on me. I was busily talking to as many people as I could when a large glass of punch was placed in my hand. As I talked I sipped until it was finished. Quickly the cousin gave me another and it was then that my husband intervened.

"Don't drink it, Mum," he said. "The punch has been heavily spiked with alcohol and you're getting tipsy."

You may think it unusual that Joe should warn me. However, in all my life I'd never tasted strong drink nor had I ever intended to. I was a born-again Christian of many years standing, and Joe said, "I could not let them do that to you."

I woke next day with a splitting headache — a hang-

over — but Grandpop said, "You helped celebrate my birthday!"

My father-in-law and I had developed a wonderful friendship and he was always looking out for my interests. He and I loved to work in the garden together. He was always concerned about my safety and welfare. He had in earlier years witnessed the brutality of his son towards me, it just wasn't so obvious these days. Still, Grandpop took care to see I was all right. I recall waking up on a Monday morning with a dreadful headache and I had not one aspirin in the house. Grandpop said, "I've got a headache tablet that might help." With this Joe got me a glass of water, I took the tablet and then I felt I was out of this world! My head spun, I saw stars. Joe was so concerned he called the medical service. Good thing it was a Monday and Doctor Turner from the Aboriginal Medical Service was at the clinic in Zillmere. He arrived with nurse Pam Mamm and, after an examination, I heard her say to Joe, "She's as high as a kite, what did she take?" The doctor was satisfied after viewing the tablet that I was in no danger, but Grandpop was in panic mode. This incident taught me never to take anyone else's tablets. I spent the better part of the day on the bed and after sleeping off what I had taken I was left with a massive hangover.

Grandpop and I shared a lot of good times together; he was truly the only father I ever knew. His grandchildren had the highest regard for him and were proud to accom-

pany him anywhere. He came from a generation that dressed up for all occasions, never going out without a tie and polished shoes, and his hat was an important part of his outfit. He was very handsome and passed that gene on to his five sons and four daughters, and to his grandchildren. He remained with us until his death, which took place not long after his eightieth birthday.

I'd been away on a week-long Christian Leadership Convention in Adelaide. We left Brisbane by plane on New Year's Day in the middle of a hot summer so I packed mostly summer clothes and was not prepared for the drop in temperature that occurred. The Queensland women attending the Conference were all gathered outside St Vincent de Paul's for the purpose of purchasing some winter wear. I returned home to discover that Grandpop had been ill so I made an appointment at Royal Brisbane Hospital's outpatients and felt I should go with him. He sat so quietly as we waited to be called (it was as though he knew what he'd be told) and when he did go in to see the doctor we together received the news that he had cancer.

He was dignified as he always was and even when receiving the news simply said, "I've got cancer."

"Yes, Dad," I said.

We had Grandpop for just one year after that day. Joe was never one to take news such as this without some outrage, but this time he did something that surprised us all. He immediately gave up the grog! That one thing he did

brought great joy and peace to the old man's heart. They didn't openly display affection towards each other, but I believe that by his actions Joe (or young Poncho) was saying to Joe Senior (old Poncho): "This is how much I love you." We buried him on Joe's birthday, 5 March. It was a time of sadness for us all, but on many occasions we'd talk and laugh about the good times that we'd had while he was still with us.

The Aboriginal Christian Leadership Convention was held in Adelaide, South Australia, in January of 1983. Many of us, who were members of the Aboriginal Evangelical Fellowship, the AEF, were sponsored by World Vision to attend this Convention. People, both male and female, young and old, came from all parts of Australia. Key speakers were leaders in churches across the world. We heard from people like Bishop Desmond Gitari from South Africa, Dr Sam Kamaleson from Pakistan, and Dr John Perkins, an African–American author from the Deep South who educated himself through study, reading and seminars.

These lectures were meant to mobilise us and prepare us for Church leadership. I found it valuable although I was leaning more to community leadership. We listened to men whose hopes and desires were evident; even though they themselves had stepped out of oppressive situations, through love of God they rose above it.

Chapter 16
Find Your Father!

As always, Saturday mornings at 4 Wavey Street Zillmere, were busy and noisy. It was often family day — and it was not unusual to have not only family but friends drop in. Joe played country and western music while he did a big fry-up of steak with onion, gravy and eggs, while my morning was occupied outside with the washing. It was on one of those mornings that Mum and Joe's sister Merna came to visit. Mum and her husband Len were living at Boondall so we saw quite a lot of her. She and Merna were good friends. She had come to accept Joe due to the respect he held for her, and because of her love for our children. Once she left Cherbourg it was difficult for her to keep in touch with her brothers and sisters, so now we were her extended family.

Goodness knows where she and Merna were on their way to. I took a break from the laundry and joined them

for a cuppa. Merna was telling us of a woman she had visited at the Royal Brisbane Hospital. I believe Merna said that her name was Ivy Saunders. The name didn't ring a bell but Mum said, "Ruth, I think you should find your father."

"What!" I said. "What would I do with a father? Do you know how old I am? I've waited all my life to hear one word about a father and now you want me to find him? Why? And what's his name?"

Mum spoke very quietly, "Frank Saunders."

"Why couldn't you tell me this when I was a kid?" I asked. "You've kept this secret all these years."

"He's probably got children by his wife and it would be good for you to meet them."

"You've got to be joking!" I said "And who's his wife and what brought this up?"

Merna explained that the woman in the hospital, Ivy Saunders, was my father's wife. Joe put his two cents worth in, "You should go and visit her, Mum."

I replied, "No!" End of subject, but I knew that it wouldn't be forgotten.

I was curious and days later I contacted the hospital and made some inquiries. I discovered Ivy was still a patient so I decided to pay visit. It was like a scene from a movie. I approached the Information Desk and asked for Mrs Saunders. The Sister directed me to where she was sitting.

"Mrs Saunders?" I asked.

"Yes," she said, "and who are you?"

I should have told her right then who I was but I simply said, "You're the wrong Mrs Saunders." I asked her where she was from, just making small talk, and found out she was down from Toowoomba for treatment. I wished her the best and hurried out to catch my bus. I was just so mad at myself, I purposely didn't tell Joe about the visit — I had no valid reason to visit the hospital, she'd probably accuse me of being a stickybeak.

For days I debated whether I should try to find a phone number in Toowoomba. I knew now that they were Frank and Ivy so I had no trouble getting their phone number — then came the hard part! With Joe working the afternoon shift at Queensland Rubber I was trying to get up the courage to ring. I was in my early fifties with a grown-up family of eight and many grandchildren, and I was about to ask a stranger: "Are you my father?" I must have attempted to dial a couple of times before doing so, then I heard the pips of the long-distance call and the phone was answered by Ivy.

I asked if Frank was there, she called him to the phone and in a quiet voice he answered, "Hello."

Straight to the point I said, "You won't remember me but you will know my mother, her name is Ruby Duncan and I'm her daughter. I think you're my father."

"You're Ruth," he said.

I wondered just how many times had he thought about

me over the fifty years. I assured him I was Ruth, to which he replied, "I thought you and your mother had died."

"No," I said, "we are very much alive."

He asked after Mum, and was she well. It wasn't a long conversation. However, I gave him my phone number and invited him to ring should he want to. He kept in touch and finally I agreed to spend a weekend with him and Ivy in Toowoomba.

I felt like a ten-year-old! With Manny at the wheel Joe accompanied me on my first visit. We arrived at a rather small house and I watched as a slightly built man walked towards the front gate. I tried desperately to glimpse something that might link us as father and daughter, however it was his hair that caught my attention. With Joe by my side I said quietly, "Oh my goodness! This is where I get my hair from." My mother had beautiful hair which she wore in braids that were wound closely into buns behind her ears. It was always tidy and I liked to watch as she took the pins out at night. It fell down her back as she took time brushing it. I often wanted to ask, "Where did I get my hair?" My hair was mousy and very fine, very unmanageable. I always wore it cut short. Every other girl in the Dormitory possessed a head of thick curly hair and every time I made a wish I wished for a head of curly hair.

Our first visit was quiet and somewhat strained. Auntie Ivy was a wonderful hostess. I didn't get to socialise with the rest of the family, that came later. Frank and I kept in

touch by phone, and he followed that up with visits to my home. This quiet, gentle man and I shared some very precious times together, but he did not disclose enough about himself. I had so many questions. I wonder now how it was that these two people who are my parents could produce a child so totally different in temperament and character, always bold and outspoken. The words frail, delicate and dainty do not suit me!

To discover I had sisters and brothers was really great. There was Helen, the eldest, very much like me. It was strange hearing her voice for the first time on the phone — it was like talking to myself! The other two sisters were Phylis and Nancy. I loved the brothers, as well as Ray who visited me in Zillmere the moment he found out about me, there were Victor and Frank, who both phoned me. We eventually met up at a family reunion. There are also many nieces and nephews; I have not met them all, but I know they are there.

A few years were all that Frank and I had, he passed away in 1987. However there are no regrets as I feel complete and cherish the words of my mother, "Find your father". For all the years of my married life I enjoyed a father–daughter relationship with my father-in-law. With him gone, even though I had no need for anyone to take his place, it would have been good to know my real father. It was with Joe's encouragement that I'd gone ahead and arranged that first meeting.

Chapter 17
Bad News

I'm Joe from the Warrego, a riptail-roaring ringer.

Joe loved Banjo Paterson's poem of the same name and when he was drinking the kids and I would often sit and listen to him recite.

I'm here, I'm there, I'm everywhere. I'm back before you know it.

We began to miss his performances — with actions thrown in for good measure — as he sang no more favourite songs, was sober and so very serious.

Unknown to any of us, even to me, he was going through some very troubling times. He coughed a lot at night and was sleeping permanently in the lounge so as not to disturb me. He began complaining of a terrible lightness in his head and very often had a discolouring of mucus and urine. My attempt to get him to a doctor was met with refusals as he said that this would pass. It was

Christmas 1985 and we had a wonderful time into the New Year. Even though alcohol was present he rejected every offer. This was truly a test of his sobriety as he always celebrated Christmas with friends. However, throughout our years together, Christmas Day was regarded as special — no drink. The last was always taken on Christmas Eve. The second week into January, on the day he was to begin work, he gave me notice that he would see the doctor. Doctor Turner's clinic was operating on Mondays. Since Joe's shift didn't start until 3.00 p.m. he thought he'd have plenty of time to see the doctor before work. I knew he'd ring me with the result of the visit but I was not prepared for what he had to tell me. It was almost 5.00 p.m. of the same day when the doorbell rang. At once I left the couch to open the door as there seemed to be urgency in the ring, as though this was not going to be a situation I would delight in.

Slowly I opened the door, not expecting to see Joe leaning against the wall looking tired and somewhat dispirited.

"Hey!" I said. "What happened? You've had x-rays, is everything all right? I was waiting for your call."

It was only then that I realised that something was wrong. Thirty-five years of togetherness and I could read his every mood.

"What is it?"

"I've got cancer and I've been given two years to live."

I stood almost rooted to the spot as he went into our bedroom. I followed him. No, this was not a joke. I felt that I had to say something. It didn't come out exactly as I wanted it to.

"How many times have I asked you to go for a check-up. Oh no, you're not going to listen to me!"

"Mum, there's nothing I can do and besides, we've all got to die sometime."

It wasn't the right time to argue. After thirty-five years of marriage even in the silence a message is transmitted. I was reminded that everything has a time, "To everything there is a season, a time for every purpose under Heaven". This was a time to weep, a time to mourn, and we did just that. Our tears mingled and washed away the pain of years of insecurities, violence and uncertainties. This was a time to love, to heal, to forgive. I didn't want to lose him, we were fixed together, and I felt his great pain.

However, the children — Merina, Duncan and Matthew — were inquiring about supper and it reminded us that life goes on. Tomorrow would be time enough to inform our large family. Tonight was ours, a time to love. Their reaction to the news was what we had expected. The boys, Norman, Duncan and Manny, grew up believing that their father was indestructible. To them he was the greatest and they tried to be just like him. As for Joe, there was the urgency to teach the old ways, and as long as he had the strength he continued to go out bush with his

dogs and his fishing gear. His journey was ending and fear had no place in his heart. He said: "We all have to die sometime", and he began preparing us all.

Tom Creed, my daughter Cassie's husband, was Joe's nephew and for a number of years they lived in Zillmere, just a street away, with their five daughters and two sons. Tom and his uncle spent many weekends together hunting and fishing. They had a wonderful relationship, almost akin to father and son. Although Tom was traumatised by the sad news he kept much of it hidden. He too was willing to soak up whatever he could so as not to forget the good times. In the first few weeks Joe and I attended many hospital appointments, tests and x-rays. However there was no good news. Joe took on an attitude of not caring one way or another, but not being able to go back to work affected him. Somehow his whole life had come to a standstill, when just a few weeks before he had been happily going to work each day and enjoying his social times on the weekends. I made every effort to ensure that he was not alone and that we would go through this together, and so began our trips to the Chermside Hospital.

On the first day as we sat in the waiting room (he held my hand in such a tight grasp) it was as though he knew how futile this visit was. Life was draining out of him and I hoped, at this moment in my closeness to him, that he would feel my strength and love pouring into him, replac-

ing his own despair. For six months we took the time to rekindle our love for each other as we talked and talked of time past. I noticed the changes in his body. He was losing weight and not eating as well. He was not one to read a book or write, so much of his time was spent thinking.

About June that same year a change came over him. His appetite returned and he began gaining weight. He was in remission and he began going out to the clubs and pubs, making regular visits to bet at the TAB and driving his old car again. I began to wonder just what this would mean to us, to our new-found relationship. I had prayed to God for Joe's wellness but would it come at a cost of losing our closeness to those other things? While he had not gone back to drinking I was afraid that he might. For Joe, remission meant recapturing a life he had almost lost, but for me it was taking him away to a life I couldn't share with him. My faith in God had not wavered over the years and if wellness did come, could we share it together in Christ? As he clung to the hope of getting well and beating the cancer he began to slide back into a very tortured state.

We planned Christmas with our family but it didn't bring *us* much joy. We watched our family enjoying themselves as the music that was played were our old favourites like Merle Haggard and Charlie Pride. I knew how it pained Joe to hear them, but he was ready to enjoy Christmas with us. I tried to raise his hopes and I searched the

Scriptures for messages of hope to share with him, however he was not ready to accept that faith in God was the only way to go. Without pressure I left him to wrestle with the unseen, but continued to pray for Divine intervention.

By August he looked like his old self. We attended the Brisbane Ekka (the Show) with the grandkids and Joe was able to enjoy himself without alcohol or cigarettes. The round Log Cabin tobacco tin that was as much a part of him as his watch and wallet was now sitting alone on the bedside table. He was happy and we held hands. I wondered if we were being given another chance. I accepted this state of grace as a gift, as it was remission for Joe. It lasted for several weeks. Tests then showed that the cancer was once again spreading. As he would not agree to chemotherapy or an operation his health began to fail. Often he sat alone with his thoughts and it was, indeed, a lonely time for him. Life went on for the rest of us as the grandkids had to go to school and I was often out attending one meeting or another.

I began praying that while the body was failing there would be healing of the soul, however it became more difficult to reach him as he became more withdrawn. The inside of the house became a prison that he had to get out of each day, and well into the night he'd sit on the back patio staring up into the night sky. It was on one of these occasions that Angela, a friend who attended the Assembly of

God Church across the road from us, asked Joe if he'd like to go to a healing service that would be held at the church that night. They were expecting many people to be there. As the Church was within walking distance he accepted the invitation and we went together.

As we sat in the pew I held his trembling hand in mine. We waited in anxious anticipation for the call to healing. I looked for some sign that he had heard the Word and that he would be convinced, in his heart, that belief in God would bring about healing. He wasn't the first to make his way out to the front and as I sat beside him I wondered if it would happen. Just as I thought it wouldn't he gave my hand a squeeze, very carefully got to his feet and made his way to the front. It wasn't long before I was right there beside him with my arm through his to lend support to his very weakened body. He waited for the visiting Pastor to touch him and pronounce healing. He was not slain in the Spirit, nor did he fall to the floor as most did.

The last hymn was sung amidst lots of clapping and after the close of service we crossed the street, walking slowly and silently back to our home. I expected him to be angry as there was no instant healing. However, it was not until we were seated at the kitchen table that he spoke.

"No healing Mum, but something happened. I believe I gave God my heart tonight." There was no denying that something had happened for his face shone and I knew then that, even as he struggled in the face of death, a hope

had arisen that would help him complete his journey. We shed tears of joy. A whole year had passed since Joe had been diagnosed with cancer and we both believed that we had, at least, one more year together. After thirty-five years of ups and downs — sometimes more downs than ups — the bittersweet love we shared kept us together.

Most nights we sat on the back steps and I read portions of Scripture to him and prayed with him. I recall bits and pieces of our conversations. He would begin with "Mum" and he was very amused when I insisted he call me by my name.

"Why?" he said.

"I just want to hear you say my name." I had become Mum, Nana, Mate. I wanted to hear my name.

"Ruth, would you marry me again if we had our lives over?" He was serious and more than anything he needed an honest answer.

"I don't think so," I said. "I would not want to go through all the pain and suffering of a battered wife again."

He insisted I write about it — about our lives.

"Ruth, I don't think you should marry again after I'm gone."

"You won't be able to do anything about it," I said. "If I need to marry I will."

"You won't ever forget me," he said. "I'll always be in your thoughts."

"That you will."

"Ruth, I'm glad I'm going first — I could not cope if you went before me. It would be better for the kids. You've always been important to them so it would be disastrous if you were to go first. I wouldn't cope, I'd be a burden to everyone. Ruth, I'm not going to see the year out. I believe God will take me earlier."

As I continue to write I remind myself just how psychic he was. He had the gift of sending thought messages to any member of his family if he needed to hear from them. I didn't take it quite so seriously. However, after he would sit meditating, trying to get a message through, the phone would ring. I'd call out, "That'll be Iris" or whichever one of the family he was trying to contact and it would be. It was something he didn't brag about, but I would bear witness to it.

Joe insisted on planning his funeral service with my help, instructing me not to bury him immediately.

"I'm going to be in the ground a long time," he said.

They were painful times, however they were times given to us by Almighty God. As we were attending Church together at the Geebung Baptist he was getting frailer and weaker, we carried a pillow for him to sit on. He inquired about Baptism and I was surprised and delighted with his request. As we talked of the procedure for Baptism he confessed that he had done many things that were not good.

"Look at the way I treated you," he began. "Wouldn't we have made a great team," he said, "working for God, our lives would have been so much better."

Sunday January 26 came around too soon. Not only was it almost Joe's birthday, but also the day we would all celebrate his new life. I watched as Pastor Steve Wade assisted him to the Baptism pool and I shed tears — I could hardly believe it was happening. I couldn't help wondering if this was the end. Truly I did not want to lose him — he was just fifty-five and I was fifty-six years old — and to get where we were now had indeed been a long hard struggle, a bittersweet journey. Our friends and families celebrated that special day with him and it was not long before we were talking about having something special on his birthday. "Never give up" was his motto and he set about making sure that whoever came was there on his invitation. This was his time to say goodbye and to repair damaged friendships. He needed to be forgiven as well as to forgive.

On 5 March 1986 a barbecue was held in honour of his fifty-sixth birthday. This was catch-up time for us. I had been fifty-six for some months and in July would turn fifty-seven. Over the years we played these age games when, for four months, I would be the *old* woman until he caught up, and it was often a secret celebration of dancing around in our large kitchen being kids again. There was no dancing that night, and our friends and relations were

shocked at his very weakened state and frail appearance. He put on a brave face and wanted no tears. I watched his courageous performance and wondered what was it that would have caused him so much pain and anguish over the years. What was it that instilled in him so much anger? When the party was over and everyone had left and the kids were fast asleep, we sat in his now-favourite spot under the stars. It was so quiet and I realised that he was crying.

"What have I done to you?" he asked. "No man could have asked for or been given a better wife."

"We don't have to talk about it," I said.

"Yes, we do." It was confession time, a time to ask for forgiveness. He was confronting his own regrets.

"Can you ever forgive me?" He was tired and his voice could hardly be heard but he managed to express a wish that I write a book.

"Tell it all," he said. "I was so cruel to you. I have found God and I regret I was not able to live His life with you. We could have been so happy."

We can't turn back the pages but I promised to write the book. Joe was the only human being who knew of my desire to write.

"Write it down, Mum."

It was my turn to speak: "I have both loved and hated you, sought God to teach me how to forgive you and love

you. I had many opportunities to leave you but you needed me and I would never have walked away."

Joe was admitted to Prince Charles Hospital. We did not know that in two weeks I would have him no longer. An early call from the hospital alerted me that Joe needed to see me at once. The Sister said that he also requested I bring the Pastor. This did not sound like one of the calls he would make at night for me to come and visit him at any hour. Other calls would be for reassurance and he made a good many of those. This one contained more urgency, Joe knew his time had come. Usually at a time like this the custom is to call together the whole family who will keep vigil until the end. I was home when I received the call.

I was there at his bedside the night before, and when I was leaving I had begged him to let me have a full night's sleep. "Don't call," I had said. I was feeling the strain of the daily visits. I travelled to the hospital at Chermside on the bus. All I wanted was one full night's sleep. He had beckoned me back to his bedside and managed to speak softly. "Don't be angry Ruth, God may take me tonight and you will feel so guilty." Yes, I would have, so I walked back to the bed and hugged him. We wouldn't part on bad terms. He had it in his mind that death could come at any time. It was his way of protecting me (even as he faced death) from that guilt stage, of thinking, "Why did I speak so harshly?" He knew me sometimes better than I

knew myself, his protection of me went back to the days we were at school together.

This call, however, was different. Peace, Joe's brother, was with us. We entered Joe's room to find him sitting up in bed. I immediately asked, "What's happening?"

"I'm going home today," he said.

"Are you sure?"

"Yes!"

The nurse entered and asked if I'd like to sponge him. Pastor Wade entered the room and like me was surprised to see Joe sitting with his legs over the side of the bed. He gestured that he'd come back when I'd completed Joe's sponge bath. Joe undid the buttons on his pyjama top and I removed it. Peace, in the meantime, stared out the window. Joe spoke of death and going like he was journeying to another town. The doctor came in as I finished and began preparing Joe for a morphine drip. He spoke of the tremendous pain that Joe was experiencing. I watched as he lay back on the pillows. Cancer does horrible things to the sufferer. This person lying on the bed didn't look like my Joe-Joe. His face was gaunt and haggard. It was hard to take.

He passed away at the Chermside Hospital. I was with him to the end and I lay beside him and held him until there was silence in the room. Pastor Wade had finished praying and left the room. Peace and I were left in that

awful silence, unable to fully accept what had just taken place.

Joe's wishes were carried out. We waited a week and after a memorial service in Brisbane we laid him to rest beside his beloved Mother and Dad at the Cherbourg cemetery. I heard the old songs being sung, they were too sad. I wanted to sing our song but was afraid to — "I Can't Stop Loving You".

Chapter 18
Life without Joe

In November 1986, not long after I had buried Joe, I received some sad news. Our beloved Pastor David Kirk had gone to be with his Lord. June of that same year, a friend Peggy Martin and I spent a week holidaying with the Kirks at Bimbadeen Bible Training College (N.S.W.) where David was Principal. In typical Cherbourg fashion we sat for hours on end and well into the night reminiscing about the good old days. As well as talking we viewed hundreds of slides of Cherbourg and its people. We were not to know that we would not see each other again.

I was driven down to Cootamundra and, along with hundreds of people, saw David laid to rest. His wife Dawn continued a life without him. However, in March 1987, just months later, we received the sad news of her death. Both were less than fifty-two years of age. We had just begun to accept we would not see Darby (David) again in

this world and then we tragically lost Dawn too. I received a letter from her weeks before, she was preparing for the June Women's Convention. She wrote about tolerance and I assumed it would be the topic for the long weekend. A phone call the night before her death was more talk on the future. She was well, although the call was from the hospital where she'd had an operation (women's business), but everything was good. We were looking forward to seeing each other in June.

At the Convention I was privileged to address the women, recognising the Kirks' strengths and leadership and remembering — once again — that there is a time and a season for every purpose under Heaven.

* * *

Life without Joe cut us off from the things he loved best. Going to the bush, hunting, fishing and camping had become less interesting because he wasn't there. He had been our leader and teacher in all things cultural and traditional.

From March 1986, after Joe's death, even though I promised not to get involved in community activities, there were many other challenges. But things would not be the same without him. Joe had asked me to promise not to get involved in community activities, this was again a demonstration of his protection of me. Our relationship at times was stormy and distorted, and he believed it was alright if I was being brutalised by him but he would protect me from others with his last breath. He'd witnessed

the stress and traumatic times I experienced while Chair-person of Koobara. I let him know exactly how I felt when I arrived home. Most times, even before I spoke, his arms would be around me. I loved the comfort he gave me, it reaffirmed his love for me. The last time it happened was the night before I took him back to Hospital. "After eleven years, Mum, you don't need this. I won't be here for you when it happens again." After his death I resigned.

Norman was keen to follow in his father's footsteps. I wasn't sure at the time if he could fit the role. Of Joe's three sons it was the eldest who would in a few years time begin to fulfil his father's dreams. I resigned from Koobara to concentrate on my own needs and the three grandchil-dren. During those next few months I realised how much they had matured. Merina was now a young lady. Evelyn (Evie) Walker, a missionary and later a lecturer at the John Haggai Institute of Bible Studies in Singapore, began vis-iting and sometimes spending weekends. It was good for me to have someone to share this time with. Christmas was over and I was still struggling to come to grips with Joe's death.

It was 1987 and Carmen and Tex decided I needed a holiday. She'd arranged for us to travel to Mareeba, North Queensland, on the Sunlander train. Evie had, by now, moved into a spare room to keep an eye on the boys and Merina. On 4 January 1987 I boarded the train at Roma Street with the Chapmans and was delighted to see Joe's

sister Norma, who would travel with us. It was an enjoyable journey for we had booked a sleeper and, while it was only meant for three, Tex joined us and slept on the floor. We broke the journey at Townsville where we stayed a couple of days with Peter, another of Joe's younger brothers. I was able to catch up with my dad whom I hadn't seen for some time. He was on holidays too, staying with Helen. We took a flight over to Palm Island to meet up with family and friends, and also attended the funeral of a relation.

It was then onto Cairns, then by car to Tinaroo Dam and on to Mareeba. It was always Carmen's desire to visit her brother Peace's ex-wife Evelyn and the children. We spent a few days with them catching up on old times and there was lots to laugh about. We were sorry to leave, however we had to return home. On the way back we travelled by rail to Kuranda, saw the Barron Falls, went back to Cairns and from there to Rockhampton for a break in the journey. I was happy to be on my way home after thirteen days away, as I could think of nothing better than to be home in my own bed. With the New Year beginning there were things to do. In January Merina moved out of home as high school was over and she wanted to try living on her own. She was seventeen years of age and I had had her in my care for about twelve years. She was more than ready for the move, however I wasn't — but it was indeed time to let go. Evelyn was still with us. The

boys were both in high school and becoming more inde-
pendent — they thought they were too old for Sunday
School!

I began helping with Sunday School teaching and be-
came active in the Women's Group at the Geebung Bap-
tist Church. In that year, 1987, I was elected President of
the Aboriginal Christian Women's Fellowship that had
been formed at the Paddington Uniting Church under
the pastorship of John and Ruth Saulo. Aboriginal women
of various denominations began meeting about one day a
week for prayer and Bible study. It was also a time for us to
catch up on family issues.

I was nominated for the position of Deacon at
Geebung Baptist Church and also became Project Man-
ager of the Pastoral Care work for Geebung and district.
With the sponsorship of World Vision we obtained funds
to employ a Christian married couple for this work. Len
and Noleen Lester answered the call from Port Augusta.
They and their three children settled into the work and
for three years developed a ministry to our Aboriginal
community. They began a youth program. At that time
we did not have the problems of alcohol and substance
abuse, just young people with too many idle hours. The
Lesters kept them busy with games nights and camping.

In 1988 I was elected to the position of President for
the Black Community Housing Service (BCHS) after
serving one year as a board member. Although I had

promised Joe that I would remove myself from community work I happened to hear young Merv Gorham's appeal in 1987 to the community for more people to take an interest in becoming members at the up-coming Annual General Meeting. I attended the meeting and got nominated for a position on the board. I served one year and then was nominated as Chairperson in the second year.

Housing needs have always been a major concern in the community. For many years Aboriginal people were up against racist landlords. There was a lot of prejudice and because of unemployment and low wages we were unable to purchase our own homes. The Government provided some assistance but the grants for low-rent housing were never adequate. ATSIC funding for one or two houses per year did not meet the requirements of adequately housing the number of families who were on the waiting list. The housing co-ops were under the management of Aboriginal people, duly elected.

The Black Community Housing Service proved to be a very difficult organisation to work with, so much so that, at the AGM of 21 November, chaos broke out which resulted in the death of a Brother. I found this very hard to handle. I walked away and vowed I would not ever get involved with the community again.

* * *

It was into the fifth month of 1989 and I was congratulating myself for the strength that I'd shown in not getting involved in other community issues. I was still involved in

Sunday School teaching, Women's Fellowship and one or two public-speaking engagements. Evie was still with me and encouraged me in speaking publicly. Evie had spent years since childhood preparing and studying for missionary service with the Aboriginal Inland Mission. Her ability to speak and teach was appreciated by the John Haggai Institute in Singapore where she was instrumental in teaching women of Asian countries about the presentation of the Scripture. She was a teenager from Palm Island when she entered Fingal Bible Training College and for years remained faithful to the cause. Evie died at seventy-three of heart failure.

Chapter 19
University

It was 1990 and I wasn't doing much — I usually lived my life going from one project to another as I was happiest when I was busy. I'd not given up the dream to write but it took so long to begin. I look back and realise that I kept myself from doing it with the idea that if only I had a better grip on the English language I could do it. So I waited. I spent lots of hours reading biographies with a view to gaining knowledge. Saturday mornings, these days, were quieter, and the memory of Joe with his fry-up and loud country music lingered. I tended to turn down the volume as, now and again, our favourite song would be played.

With the *Courier-Mail* spread on the table I'd turn the pages without the interruption of "Give me the sports page". One day an advertisement caught my eye — in fact it excited me. The Carseldine College was offering places

to mature-age students as well as places for Indigenous people. At once I knew I'd apply. I did and was given an interview. I was lucky to be accepted. The course that was on offer was a Bachelor of Social Science. Naïve as I was, I only wanted to learn English because I wanted to write! And so began my career as a uni student in Semester One, 1991, at the Carseldine campus of the Queensland University of Technology.

I was completely alone and I had the feeling in that first week that I had bitten off more than I could chew. Talk about a fish out of water — just about everyone around me was so much younger and so focused! Amidst all of this I felt every bit of my sixty-two years. After forty-eight years I was re-entering a system of education that had been denied me so many years ago. I remember thinking, *Control yourself, Ruth*. I was almost ready to turn around and go home, this was foreign territory. However, I had overcome other obstacles of life that had been thrown at me and I'd met those challenges so this was just another bridge to be crossed in my quest to get ahead.

For eight months I sat in lectures, took part in tutorials and wrote up notes — I was writing! However I was not comfortable even though the group that I was attached to, for study purposes, was great. They would not have known that I had such turmoil going on inside me. I was still caring for Duncan and Matthew, but it wasn't the travelling or indeed keeping up with things like the house

work — it had more to do with trying to fit into a system of learning and not being fully prepared for it.

Glen Guy's lectures on "Dealing with emotions and what are they?" seemed like a camera within me that was somehow screening my personal emotions for all to see. There didn't seem to be any other Aboriginal people around and I was very aware of my Aboriginality. I felt that I walked the corridors and classrooms trying to act and behave in a manner that appeared normal, always wondering if anyone looking at me could observe the fear that threatened to take over my life. The real crunch came when we were required to write five hundred words on the subject "Fear of Disclosure".

What we had to do was put our emotional state into words and tell people about ourselves and our wants. I began to write, identifying my feelings and emotions and, as I put them into words, I realised I was writing about myself — things that I had concealed for many years. I was gripped by a tremendous fear of what I had done. It was obvious I was not ready for self-disclosure. I tried, it was hurtful — shameful, it wasn't the right time. I went to see Ross Daniels, he was the man to see. With my assignment under my arm I entered Ross' office and simply said, "I quit!" As he talked to me I heard what he was saying. However I was not ready to bare my life to anyone. I guess it was some sort of defence mechanism, and even though I knew what this behaviour was all about I was not ready to

reveal or disclose. Funny isn't it, since a few years later, in 1998, I wrote and published my first book *Is That You, Ruthie?* I value the eight months I spent at Carseldine and occasionally meet some of the group who are now all professionals in the Social Sciences.

This experience at university was one of the things that prompted me to find out more about my past. One unexpected source of information was the file kept on me by the Department of Native Affairs. In *Is That You, Ruthie?* I write about how awful it was to read the things they wrote about us. There were plenty of shocks and surprises in that file, including Ministerial letters to and from the Deputy Director of the Department of Native Affairs and the Superintendent of Cherbourg with the intent of exempting Joe, me and our two children from Cherbourg. Exemption meant that you were no longer under the control of the Government, but it also meant that you couldn't live on any Aboriginal Missions or Settlements. So exemption for us meant that we would have to move away from Cherbourg and get a permit every time we wanted to come back and visit. My mother had obtained an exemption, that was why she had to get a permit to come to Cherbourg and visit me and her parents. I was surprised to find application forms for exemption — Joe or I hadn't filled them in.

"The Aboriginals Preservation and Protection Act of 1939"

REPORT ON APPLICATION BY ABORIGINAL OR HALF BLOOD FOR EXEMPTION FROM THE PROVISIONS
OF THE ACT.

Questions	Answers
Name of applicant	RUTH HEGARTY
Sex	FEMALE.
Age	26
Where born	CHERBOURG 14. 7. 1929.
Name and Breed of parents -	
Father	UNKNOWN.
Mother	RUBY DUNCAN H.C.
Were parents legally married?	—
Is applicant married (legally)?	YES.
If so, what is nationality of wife (or husband)?	JOE HEGARTY JNR.
Does applicant (or his family) habitually associate with aboriginals?	No
Does applicant live in a civilised manner and associate with Europeans usually?	YES.
Is applicant of good character, steady in employment and industrious?	YES
Does applicant drink?	No
Or, procure it for other aboriginals?	No
Is applicant educated; to what extent?	4TH GRADE STANDARD
Is he (or she) thrifty, and does he (or she) understand the value of money?	Yes
Is he (or she) intelligent enough to protect himself in business dealings?	Yes
What amount has he (or she) to credit or debit in the Savings Bank?	—
Has applicant previously been granted exemption?	No
Remarks!	DUNCAN (GLENYS(RICHARD)) (3). MORANY (HEGARTY) (2).

RECOMMENDATION OF PROTECTOR:-

(State whether exemption is recommended. If so, whether from all provisions
of the Act, or only part. In latter event, state provisions which should remain
applicable.)

A copy of the letter to the Deputy Director, Department of Native Affairs, Brisbane, from the Superintendent of Cherbourg dated 17 March 1955 reads:

Re Exemption Joe Hegarty Jnr and family

Attached is a completed application for exemption in respect to Joe and Ruth Hegarty. Joe Hegarty has been employed for some time with the Forestry Department. He has a Savings Bank credit of approximately thirty-one pounds. Joe Hegarty is young and intelligent and is quite confident he can manage his own affairs satisfactorily. The fact that Joe has been able to hold his job with the Forestry Department confirms his confidence in himself.

They had to be joking! Holding down a job with approximately thirty-one pounds in the bank would not have been incentive enough to persuade my husband to leave his birth place.

A reply from the Acting Deputy, Director of Native Affairs dated 30 March 1955 reads:

Re Joe Hegarty Jnr and Family

As recommended by you I enclose herewith Exemption Certificate in favour of the above. When they are ready to leave the Settlement please issue such to them and forward their written acknowledgment to this office. No recommendation had been furnished by you with regard to Joe Hegarty's Savings Bank account.

With respect Joe had a child for which he was contributing maintenance. You may consider it advisable to retain his Savings Bank balance against such payments. Please forward your recommenda-

tion on this matter.

Please advise as to the Post Office Ruth Hegarty will collect her Child Endowment payments in order that the necessary arrangements can be made with the Department of Social Security.

Another piece of correspondence also dated 30 March 1955 states that "the Certificate of Exemption is to include children Glenys aged 5 and Norman two years".

A second letter from the Acting Deputy Director to the Superintendent, dated 15 June 1955, reads:

Re Joe Hegarty Jnr and family
Exemption Certificates in favour of the above were forwarded to you on the 30 March last, but to date no acknowledgments have come to hand nor has any advice been furnished as to whether they have left the Settlement and if so where are they residing. Please advise.

So, since 1955 the Deputy Director of Native Affairs and the Superintendent of Cherbourg were corresponding in an effort to exempt Joe, our two kids and me from Cherbourg. From correspondence in my personal files it seems we were to be a test case. I try to imagine how meetings with the Super may have affected Joe since he kept them secret, I was never informed that they had ever taken place.

Any meeting with the Superintendent meant that you were summoned to come before him. That in itself would be very daunting and would raise questions in your mind. Joe would not take too lightly the threat of being forced to

leave Cherbourg. He had done nothing wrong — something the Authorities thought of as wrong-doing was usually what constituted a reason for removal. Joe would not have known that the reason the Superintendent was considering exempting us was due to his not contributing to the dreaded Welfare Fund. This kind of threatening and intimidating of families was one method that was used to control us.

A letter from the Deputy Director of Native Affairs to the Superintendent of Cherbourg dated 11 July 1955 reads:

Re Joe Hegarty and Family

Further to your communication of the 30th ultimo and discussion with Mr Davis on the case of this man and others similarly placed, it is appreciated that Hegarty is not receiving good economic training being allowed to live rent free, in a Departmental house and have his family kept subject to contributing only 10 percent from his gross earnings.

However, any action to collect any increased amount will require an amendment of the Regulations and will involve submission of a special case. Possibly Joe Hegarty's case would be a good test case. Your views on this matter will be appreciated. At the same time will you please advise as to the gross weekly wages he is receiving so that the matter can be considered further. An indication as to the number of other men there are on the Settlement similarly placed together with names of their employers would also be helpful.

The reply dated 30 June 1955 from the Cherbourg Superintendent notes:

Re Joe Hegarty Jnr and family

In reply to your communication of the 15th inst that you are advised the above and his family are still resident on this Settlement. Hegarty has recently been off work owing to an injury to his eye and has advised that he was unable to secure the house which he understood was available at Kilkivan.

I am very much of the opinion, following my conversation with Joe Hegarty today that he is not making a great effort to secure accommodation. His reply to me when I was enquiring from him re his efforts to secure accommodation was "You cannot force me to leave the Settlement."

This man has a Savings Bank credit of seventeen pounds sixteen shillings and five pence after nine months continuous work at award rates with the Forestry Department, plus the assistance received from the Settlement during that period.

The Exemption Certificates will be retained at this office and Joe Hegarty will be reminded that they are available to him.

I read the files with such trepidation — how could the Authorities not know that such a move would have a stamp of fear attached to it? Joe lived in the camp at Cherbourg all of his life and he knew the intolerant action the Government took against people who dared to return to Cherbourg. This would, no doubt, impact on Joe in a way that would threaten his relationship with his family and friends. Outsiders needed permits to visit Cherbourg and time restrictions would be placed upon the visit, for example, it might be limited to a weekend. To overstay that permit involved intervention by the police plus a

meeting with the Superintendent. The permit was a threat and put us in a position worse than what we were in at the time. All Joe needed to hear was that going outside Cherbourg posed a threat that would disadvantage him and disqualify him from ever returning. It would appear that our bank balance was what caused the Department to seriously consider our family for exemption.

Chapter 20
Burringilly and Nalingu

My involvement with Black Community Housing Service and my months at university were now things of the past. "I'm gonna stay home and do my own thing!" I said. Desperately trying to cut myself off from my life of involvement in community issues, I believed I was given a second chance to acknowledge my promise to Joe to "stay out of the community organisations". It wasn't so much that I had promised but that I agreed with him when he said, "After I've gone you'll have no one to support you." There was no one else who knew me as well as he had done and the brunt of all my anger, frustration and hurts had impacted upon him. He allowed me to do it without criticism and his words were, "Get out of it, you don't have to be there", whenever there were problems. Of course I'd go back, simply because I loved the involvement, and he knew I would. But he had been my only support person.

A year later I received an offer from the office of the Honourable Peter Staples MP, Federal Minister for Aged, Family and Health Services, to sit on his advisory committee to represent older Aborigines. As well, there was an offer to sit on the Queensland Consumer Forum for the Aged. After talking with family members who, mind you, were concerned about me sitting at home doing nothing, I accepted the positions. I was a little out of my depth on the Commonwealth Advisory Board because it was made up of professional people, doctors, health professionals and leading church people whose involvement in older persons' issues such as nursing homes; the Home and Community Care day respite; and aged care, just blew me away. I felt like a flea in a room full of hounds. I had no idea what everyone was talking about, these ageing issues had never before confronted me. Questions began to form in my mind. Who was servicing the older Aborigines? Why weren't we doing it ourselves? Was there at least one day respite centre for Aboriginal Elders? If so, where was it?

I was surprised when the Office of the Ageing contacted me about a survey that had been conducted by Black Community Housing while I was Chair, on the aged people from fifty years and over living in the Brisbane City area. They had agreed to pay BCHS for the consultation work, and the board employed Norman Hegarty to conduct the survey. When completed, it had

been sent back to the Office of the Ageing. I was approached by the Office which, by now, had some unspent monies and they wanted me to nominate an organisation that might accept the funds and agree to set up a pilot program for a day respite centre for Aboriginal and Torres Strait Islander aged and frail people.

I was very excited! For weeks I had been asking questions and seeking answers about respite centres. I nominated the OPAL Centre as a worthy committee to take up the project, and I attended two meetings with OPAL as a representative of the Advisory Board. For months I heard only scraps of information of progress, but was more than satisfied that everything was going well. The Advisory Committee met monthly. I was surprised when I received an invitation from the newly formed Woodridge ATSI Day Respite Centre's co-ordinator, Martin Watego. I was delighted to know that the Respite Centre, a project of OPAL, was in operation and Martin was meeting with the Elders of the community to set up the Centre's very first Steering Committee. I was invited to chair the meeting. It would be an honour as I believed I had, in a small way, helped in initiating the project, so I agreed to do it.

At the meeting there were about twelve Elders and I was feeling a bit awkward for, not only was I out of my geographical area (I'm a northsider and Woodridge is on the southside), but some of my Elders were not particularly happy with me because of the hard stance I had taken

with Black Community Housing Service at the time I was the Chairperson. The Elders opposed the board's decision not to favour emergency housing applications over those due for processing. Instead, the board chose to administer help through a scheme it had adopted, of emergency housing for the interim period.

"Have they forgiven me?" I asked myself.

These Elders were the matriarchs, the great ladies who began life as domestic workers, who had spoken out against oppression. These were women whose fighting spirit was invoked by the power struggle between other political factions, and who channelled their energies in pursuit of shared goals against discrimination and injustice, and for equal rights. I held great admiration for them all, particularly Auntie Janie Arnold, Auntie Jessie Budby and others. With kisses and hugs all round I was forgiven and it was time to get on with the meeting. I explained that OPAL was the overall manager of the newly formed Centre. However, a steering committee was to be set up to report to OPAL about procedural matters. Most of the afternoon was used to explain, listen and answer questions. We closed the meeting and before leaving I reminded them that Martin would set up another meeting at the same time next month, and it was important that one of them be elected to chair the meeting.

"Ruthie, you're chairing it, aren't you?" This was from

Auntie Janie (my mother's full cousin and someone you don't want to mess with).

"No!" I said. "It has to be one of your mob."

But there were no arguments as everyone agreed with Auntie Janie that I should be the chairperson. These were my Elders and no disagreement or excuses would be entertained! So I became the Chairperson of Woodridge Day Respite Centre. Going back home to Zillmere in a taxi I silently spoke to Joe, "I've done it again!"

For three years I remained Chair of the Steering Committee and saw clientele numbers reach fifty-plus. During this time I took the Committee from under the management of OPAL and finalised the first General Meeting after they became a constituted body. Again, these were not always easy times and I was ready for retirement. However I was asked back the following year to take a place at the official naming and opening of the Centre. The name chosen was "Burringilly" (meaning "stepping out together") ATSI Day Respite Centre. It was a proud moment indeed, a pilot program becoming a reality, a successful project. As we drove home to Zillmere in the bus, the group of five whom we usually took out to Woodridge for respite care sat talking between themselves and then began to question me about their future.

"Do we still have to go out to Woodridge? All that travelling takes it out of us. Sister Ruthie, why can't we have our own respite centre on the northside?" This was Sister

Tilly speaking. She loved her day at Respite, but if we had a northside program it would cut out much of the travelling. I'd heard it so many times as we travelled back and forth that I tended to ignore it. Once more I was about to be freed to do my own thing; I didn't want to get mixed up yet again in all the seemingly endless tasks of forming another committee. However it happened, and I found myself once again doing what I said I wouldn't do.

Even as I began to look forward to some sort of retirement I was easily talked into starting a new project.

"Come on Sister Ruthie, think about it, no more long bus rides back and forth to Woodridge."

I couldn't say no. "Why not?" I answered. I promised to look into it.

Queensland Health, and Home and Community Care were ready to hear our proposal and finally the project was approved. Then came the hard part — home visits to potential clients, a suitable venue from which we could operate, advertising for staff, purchasing suitable equipment for the office, etcetera. I knew I couldn't do it all myself so I enlisted the help of my daughter Moira, who just happened to have taken three months Long Service leave from her Government job. Without her we would not have been able to deliver the program in the time that we did. My brother-in-law Peter was now the Project Officer for Home and Community Care. He gave us some wonderful assistance.

Geebung Baptists offered us the use of their hall for a short time, that is, until we were able to purchase a suitable building. On 28 September 1994 a committee was formed out of the client membership. We began with almost thirty clients. Burringilly ATSI Day Respite acted as our sponsor for the purpose of receiving funding, as we were not yet incorporated. I had been acting as Chairperson. For months we worked towards becoming legally constituted and, furthermore, towards our release from Burringilly. In September 1995, at our general meeting, we formally adopted the name "Nalingu" from the Goongurri language, meaning "yours and mine". We finalised our deal with Burringilly and were ready to go it alone. A property was purchased in Zillmere, it was restructured to the Government's Home and Community Care standards and, after eighteen months, we moved from Geebung to our new premises on the corner of Colberg Street and Handford Road. This worthwhile service to the frail, aged and disabled is still operating.

Chapter 21
Bitumen Dreaming

It's ironic that it should be Norman who naturally took on the love his father had for our cultural ways. I remember it was in 1992 that the United Nations observed the International Year of Indigenous People when Norman rang me and asked, "What can we do?" He was keen to get involved. I had just finished *Lengthening Shadows, Durundur Country*, the account of the Dungidai people who were relocated from the town of Woodford, their ancestral land, to Barambah in 1905. Five hundred people were forced to walk the two hundred and thirty miles. As I read the account to Norman over the phone we both knew what we were going to contribute to the International Year. Our plans soon got under way: we would re-enact the walk.

What led to the Dungidai people's removal were the increasing numbers of people settling in the district. The

land occupied by the Dungidai people was considered valuable, so the Government decided it needed the land and that removal was necessary.

Around the hottest part of the summer of 1905, the first group of Dungidai was packed up to be deported to Barambah (now Cherbourg) Mission. Those who could not walk the distance — the aged, women, and small children — were sent by train or wagons. The rest walked.

The fact that it took them ten weeks to complete the journey tells us that they would have endured hardships. The route taken was over the Blackbutt Ranges, and mostly through heavy scrub. The summer heat would have caused storms, hunting for food would have been difficult, and water for drinking wasn't easy to find.

Many weeks of planning took place and we sought the help of some skilful people who volunteered their time. The name of the project was "Bitumen Dreaming Path" because, unlike the Dungidai, our journey was along the highway. Fifteen young people were chosen, two girls and thirteen boys, black and white. They were from north-coast high schools, this was the closest we could get to identifying the appropriate tribal groups from that area. They came from Years Ten and Eleven, fourteen- and fifteen-year-olds. The re-enactment of the trek to Cherbourg was never going to be easy, and the young folk were briefed on some of the difficulties they might encounter. They were also briefed on the history of the re-

moval and the tragic events leading up to it. They were told it was going to be an exhausting journey. However, when given the opportunity to pull out, every single one was keen to go.

We met at the Woodford State Primary School on Thursday 24 June for a barbecue before moving on to the original campsite of the Dungidai tribe. Since the 1905 removal no Aborigines have resided in Woodford.

The walk was exhausting, sometimes entertaining. With blistered feet and tired bodies the young people walked and experienced a history that took place many decades before they were born. From town to town along the route we were happily received by the locals. They provided hot meals and baths, and we had time to sit and chat around the campfire. We chose the colder months for the walk, late June and early July, 1993, as there would be less danger of encountering snakes. We had just two eight-person tents to share between us all. The two girls shared a tent with Veronica, the nurse that the Aboriginal Medical Centre loaned us; Inez Kyle, who was our cook; Cassandra and me. The boys shared the other tent, and some would camp around the fire.

The trek began each day after breakfast with short breaks for drinks and fruit at 10.30 a.m. and 3.00 p.m., and a longer break for lunch. Our funding came from ATSIC, with their generous contribution we were able to

equip ourselves with what was required for camping, transport, food, and petrol.

Some wanted to quit, they found it real hard. But the reminder that, since we were doing it with more comfort than the original walkers, helped them see the distance. Not one of those young people gave up.

After ten days of continued interaction with the youth it was obvious to us that not enough work was being done to introduce the younger kids to appropriate cultural experiences. I remembered how, in times past, Joe and I had great times introducing our children and grandchildren to things cultural.

Joe's dream of a place to pass his culture on to the next generation was realised after our ten days of treking from Woodford to Barambah. That walk was to be the beginning of what is now known as the Binambi Barambah cultural enrichment camps, an ongoing program of bush camps, storytelling and building relationships. Joe was with us all the way, and I saw in Norman the same dedication and love for things cultural that were his father's. The forty participants included the youth and our resource people — the cook, Inez Kyle; Cassandra, our nurse Tex Chapman, our driver of equipment (who was always ahead of the group to set up the next camp) and our two cameramen who videoed the walk from start to finish. Now, ten years on, media students at Griffith University are using the video tape to make a short fifteen to twenty

minute film of "Bitumen Dreaming". It'll be released late in 2003.

The kids, with the assistance of Paul Kelly who joined up at Moore, helped us to celebrate the International Year by putting together a song to commemorate the ten days. Of course it was called "Bitumen Dreaming". I was then sixty-four years of age, and Joseph, Norman's ten-year-old son, was the youngest to complete the walk. We called ourselves "Binambi" because that came from the Reserve (Aboriginal) and "Barambah" — the finish of the walk. The one hundredth birthday of that event is due in three years and we have had talks to make this walk an even bigger event.

The following year we commenced the camps for disadvantaged Aboriginal children under the name of Binambi Barambah, which the family of Joe Hegarty Jnr incorporated, in the memory of their father.

Chapter 22
Boundary Street Curfew

The history of the Boundary Street curfew in Brisbane has been well documented over time and has been talked about often by older Aboriginals with mixed feelings — sometimes with fear and often with humour. They were very resourceful in their responses to what was meant to be an exclusion of Blacks from the city area as dusk fell. Some, like my mother Ruby, were live-in domestic servants, most lived on the fringes of suburbs. They would come into the city to shop, and then later to socialise at hotels and dance halls that were known to be friendly.

The Second World War was in progress and Brisbane was alive with servicemen from the USA. The restrictions that applied to Aborigines concerning the Boundary Street curfew also applied to the African–American servicemen. My mother was in the employ of the Simmonds at Indooroopilly. Mr Simmonds was a photographer.

Mother was at peace with herself after years of pastoral work as a domestic, seeing no one, going nowhere, so life in the city opened up a new way of life for her.

I was about fourteen years of age when Mum made her last visit to me at the Dormitory. Her move to the city was about getting on with her life. For years she was bound by the regulations that she contribute to my up-keep in the Dormitory. I would soon be working for my-self and this was her time. She had changed, she had become more talkative and outgoing. I sat and listened to the stories she and the women who worked in Bris-bane told. They laughed and laughed, there were no sad stories. I heard about the curfew and about Boundary Street, and that the curfew provided some anxious mo-ments for those who missed the bus back to the southside.

Everyone looked out for each other. The work of many of the women was still controlled by the Department and they joked about putting it over Miss McCreedy, the De-partment's Head Clerk. The women, on their days off, would report to Miss McCreedy before venturing out into the city, and she would receive a call from their mistresses next day if they were one minute late returning. Mum told the story of the night she and Auntie Rita Huggins (née Holt), who'd become her best friend, nearly had a falling-out. It happened at the bus stop where quite a

crowd had gathered to catch a bus back over the bridge. Rita was late and Mum began pacing up and down.

"Rita better not miss this bus," she said, out loud.

Finally she arrived and an argument began, became very heated, and was followed by a bit of a punch-up. Their concern for each other and the drastic consequences of a damaging report to Miss McCreedy was what led to these two good friends resorting to a fight. Mum said, "We had to look out for each other."

Mum hit out first. Auntie Rita called out, "Wait a minute, Dunc, I want to take my step-ins off." Right there on the bus stop she removed the step-ins (a sort of elastic girdle), just as the bus arrived. Rita, with her girdle clutched firmly under her arm, and Ruby both got on. They rode the bus together to Indooroopilly and I believe that by the time the two friends got off the bus, fighting was the last thing on their minds. It was more important that they hurry to their place of employment before midnight. They were of good character and wanted to keep it that way.

I can hear them still: "Hey Ruby, remember the night at the Boathouse?"

"Yes, Rita."

"What happened?" I asked.

"Rita danced with an American (Black) and slipped over during a hot number."

"Yes?" I said, waiting for more.

"I don't think you should hear this, Ruthie," said Mum.

"Come on, she's fourteen," Hannah Walsh said.

"As Rita got to her feet she muttered 'bunthey'." (This meant a woman's private parts and was considered very rude — we weren't allowed to say it in the Dormitory.) "Her partner asked her what it meant and, since it would have been too embarrassing to tell him, she said 'darling'. When he escorted her back off the dance floor he thanked her and called her 'bunthey'. When Rita saw the looks of the other girls she said, 'That means *darling*!' "

All night the girls were lovingly called "bunthey" as they struggled to keep a straight face.

I couldn't wait to tell the other fourteen-year-old Dormitory girls!

Both Mum and Auntie Rita were in their late thirties at this time. However, the impact and control by the Department over their lives was always a reality. I heard that story many times and they both not only enjoyed telling it but provided the actions as well.

It was because of those curfew stories that I wanted to take part in the "Bringing Them Home" Walk that was organised by the Indigenous Advisory Panel under the auspices of Lord Mayor Jim Soorley on 7 February 1998. The walk from Musgrave Park to King George Square was organised as a clear statement that the Boundary Street curfew, part of the Act that excluded all Blacks from the city area at dusk, no longer existed.

It was good to see the involvement of Church and civic leaders as well as trade unions in the "Bringing Them Home" Walk. Most of our Elders were bussed in on the route while others walked. My involvement was to be minimal. I recall it was a Saturday afternoon and, while waiting to be picked up, I began making a little doll out of scraps of material, just as I had done as a child in the Dormitory. I'd just completed it as the bus pulled up and, after showing it to Viola Button, my old friend from our Dormitory days, I placed it in my pocket. That doll became the focus of an impromptu speech I was asked to give at the Square, before 15,000 Brisbane people who had gathered to welcome those of us who made the after-dusk walk declaring the Boundary Street curfew obsolete.

When I spoke of our incarceration and determination to survive the system that denied us access to toys and books, I held the doll up for all to see — it was only two inches long with stick arms and stick legs. I explained that with resourcefulness, we were able to create a toy that gave us some pleasure. In response to the many restrictions and exclusions we coped by using whatever means we had to alleviate the fears and frustrations. Humour and resourcefulness were, in essence, the circuit breaker that prevented the system from overpowering us. That was, in fact, *our* Boundary Street.

My public speaking "career" did not begin that night, I

had been doing it for some time. However I took on a bolder approach — almost as if I had come of age. Fear of the past has since disappeared.

Chapter 23
Take It or Leave It!

We lived and worked with the same desires for a better life as did all Australians. However the reserve system, whose main aim was supposed to be to improve living standards, did nothing to encourage self-esteem or self-motivation. All those years we lived at Cherbourg, money for the so-called Welfare Fund was taken from Joe's wages without his permission. When we Dormitory girls were out working as domestics we only received part of our pay. They called it "pocket money" but it was our wages, and we had to apply to the Superintendent at Cherbourg if we wanted any more of it. We saw very little of our wages and were never told where the rest of it went.

The history of the Queensland Government's involvement in the financial affairs of Aboriginal and Islander people was hidden under legislation going back to the period 1884 to 1965. Since the Protection Act of 1897 the

Queensland Government had control over every aspect of our lives — declaring all Aboriginals to be wards of the State and controlling where we lived and worked, the amount we earned, how much of our earnings we received as "pocket money" and how much was banked. Because generations of Aboriginals interned on missions and reserves were not aware of the politics behind these aspects of control, it's not surprising that they unknowingly accepted government control of almost everything they earned.

The demand for labour was on the increase from 1906. The rural sector, including pastoralists and agriculturalists, hired their labour from Barambah (Cherbourg) and other reserves through the Chief Protector, who realised that the more inmates he sent to outside employment, the more he could make by putting a charge on their wages for the support of the reserves. With this income it was envisioned that reserves all over Queensland would become self-sufficient and self-supportive. But this didn't happen. Indigenous people living on reserves saw very little benefit from all that money. In fact, lack of basics like clean water and sewerage led to disease and death, such as from gastroenteritis at Cherbourg and on Palm Island.

Since 1904 the wages of Indigenous workers went directly to the local "protector of Aborigines", often the local policeman, and "pocket money" was paid to the worker. From 1910 the Government took levies from the

wages of all people living on reserves. So even though we didn't have any say in who we worked for or where we worked, and we would be sent out on contracts lasting six or twelve months, we still had to pay for the upkeep of the reserves. Over the years millions of dollars of our money was held by the Government; we never saw this money or any of the interest that it earned. Even though there were many audits that revealed poor administration and the lack of accountability for our accounts, there were no checks on how the police protectors or the Government handled our money. For years the Government paid Indigenous people much less than award wages, even though they knew it was illegal. It wasn't just unpaid and under-paid wages, we also had money withheld from trust funds, Child Endowment and Workers Compensation.

It was around 28 January 1994 that I first became aware of the fraudulent manner in which successive Queensland governments continued these practices at the expense of a people suffering the effects of poverty. I was attending a protest against injustice, we marched from Roma Street Forum to Musgrave Park. There I met up with a few "girls" and, as always, we reminisced about the old days. We were approached by Lesley Williams with clipboard and petition in her hands. She invited us to sign up to protest about lost wages.

I don't think any of us signed. Our reply was "Thanks, but no thanks!" We laughed with amazement as Lesley

walked away. We said to each other "How could there be lost wages when we earned so little?" Months later a newspaper article by Tony Koch and Racheal Moore caught my attention. "Lesley Williams, 52, of Gympie won an historic apology as part of an out-of-court legal settlement brokered with the State Government." It was after that time that I began hearing talk of "stolen wages and savings" and the "Welfare Fund."

In 1985 seven Palm Island workers brought an action in the Human Rights Commission against the Queensland Coalition Government for underpayment of award wages. Palm Island was not only the place that was used as a threat of serious punishment for us when we were at Cherbourg, it was a reserve where malnutrition and disease were common and where workers were paid much less than the award wages. In 1996, after losing a court battle on which they spent nearly $1 million, the Government was forced to pay the workers the sum of $7,000 each.

In 2000 the Queensland Aboriginal and Torres Strait Islander Legal Service Secretariat (QAILSS) began a collection of two thousand testimonies with a view to taking legal action against the Queensland Government to recover the wages people were owned. I was asked if I'd filled in a form — I did not, I wasn't that interested at the time. QAILSS's case for compensation included not only the wages and savings, but also money from the unused

trust funds, unpaid Child Endowment, Workers Compensation and deceased estates.

My interest peaked on these particular issues when I was invited to a book launch by historical researcher Dr Ros Kidd, author of *The Way We Civilise*. For me to actually involve myself in any controversial issues I need evidence. This account by Ros Kidd provided me with everything I needed to get involved. Then, as a member of the Aboriginal and Torres Strait peak advisory board to the Queensland Government, I was one of the three members who were nominated to place "Wages and Savings" on our already full portfolios. This meant we would speak on and involve ourselves in the wages and savings debate.

In 2002 the Beattie Government made an offer of $55.6 million as a reparation payment to some hundreds of Aboriginal and Torres Strait Islander people, of between $4000 and $2000 each, as settlement for all claims, according to the amount of time they lived under the Queensland Protection Act. This offer would affect those Aboriginal people who were alive on 9 May 2002, born before 31 December 1956, and who had lived subject to Government controls over their wages and savings.

Of course there was no justice in this offer. It was made at a meeting at Parliament House by the Premier and the Minister for Families, to members of QAILSS and the three Advisory Board representatives, me included. Hours

previous to this meeting we three Advisory Board reps had met with QAILSS to view the proposal that they intended to present to the Premier. It seemed good to us and we were willing to fully support it. But the QAILSS proposal did not hit the table. The Premier's offer of $55.6 million was put on the table, with the Premier strongly insisting it was a "one off" offer — take it or leave it! As I sat at that meeting I felt as though I was back in Cherbourg — this final decision was made without negotiations or input from the average Aboriginal person whose life was lived under the same oppressive, domineering manner of previous government.

Immediately I got involved in protest meetings with community groups, calling on the Government to further negotiate with the people affected. However, as much as we protested it fell on deaf ears. The situation as it stands now is that payments will be made to at least 12,000 past workers, at the allotted rates of $4000 or $2000. So far, at the end of May 2003, only one person has actually been paid, and the money has in effect become a funeral fund! Each person accepting the payment has to sign an indemnity that they will make no further claim against the Government. Our old people are ageing and as time passes there will be fewer of them left to accept the money. Their families won't receive it in event of their deaths, it will only be paid by the

Government to cover the cost of their funerals or, in some cases, only part of their funerals.

Chapter 24
Journey's End?

Does a journey end when the one on the journey is still alive? Just as surely as I want to write the final chapter another memory, another time, another place comes to mind. Three years of writing, many tears, lots of anger, times for forgiveness, to recall love shared.

"Close the book, Ruth," my head tells me. "But what about …?" my heart replies.

There is always something else to write about and one such event happened a few days ago. I was on Thursday Island attending a meeting of the Aboriginal and Torres Strait Islander Advisory Board. It was on the final day of our four-day visit, a name caught my eye. In a moment of time I stepped back sixty years!

It was 1942 during the Second World War and a good number of families were being evacuated from Thursday Island. I was thirteen years of age, without any knowledge

of the War and what it was doing to this country. It was only when some of the evacuees were placed in Cherbourg that it became real. We were aware that the children from those families would be attending school. Nothing like this had ever happened before at our school.

"New kids!"

We all wanted to have one of the newcomers in our class. The closest we in Grade Four got to a new kid was when a boy was put in a lower Grade Three class. We learned that his name was Ishmael Shibasaki and that he was Japanese. He hung out with the boys from Grade Three. Joe Hegarty Jnr and his friends Arnold Bone, Walter Hill, Frankie Carlo, Leslie Williams, Jack Moffit, Angus Rabbit, and Bill Fisher took him under their wing. Other members of the Shibasaki family were put into various lower grades. Just a few weeks it was, and then they were gone — but not forgotten.

Now in 2002 I looked at the name on the proposed project as it was handed to me, and I could not tear my eyes away. I heard what the young lass was saying.

"This is my project and I'm presenting it to your board for approval. What do you think of it?"

Without answering her question I spoke.

"Is your name Shibasaki?"

"Yes." She had my attention, however it was not because of the project.

"I knew of a boy with that name who was evacuated to

Cherbourg with his family during the Second World War."

"Yes," she said, "that would be my family." Her family?

"The Shibasakis were Japanese," I said.

"Yes, my mother is Torres Strait Islander."

"Who is your father?"

"Ishmael," she replied. I felt the excitement rising to my chest. Can there be any more surprises for someone of my age?

"I can't believe this. Can I ask if he is still alive?"

"Yes, he is. Wait, I'll get him on the phone."

I heard her say, "Hello, Dad, I have someone here who knows you. Her name is Ruth Duncan from the Cherbourg school."

I was delighted he remembered me and I was sad, too, because I would be leaving the next morning. But since he lived on Horn Island where I was flying to, he could meet me there on the wharf. His daughter said, "You will know him, he'll have a towel around his neck."

Although this was an exciting occasion I wanted Joe to share it with me. This was taking me back to a time we had shared, this was a friend. Joe would remember many things about those times. He would say, "How about that, Mum? You just wouldn't believe it!"

As the ferry slowly made its way in to dock I was almost too afraid to seek Ishmael out on the wharf. I imagined he'd be waiting a fair way back. He waited on the end of

the gangplank. I knew him because of the towel. He stepped forward and embraced me. In that one instant sixty years melted away like the morning mist. It was as though we were the only ones there. As we walked along the wharf to my waiting bus, arms around each other, I wanted Joe to be there.

We spoke the names of our past and as each one was mentioned I sadly recalled, "They're gone!"

Silently I sat in the bus and returned his wave as the bus moved forward. *Does the past ever die? Joe, I have something to share with you. Remember Ishmael?*

Sadness filled my heart as reality hit me. Joe's gone and this is our story. Because of this book it will live on to a future that we will know nothing about. Our journey will have ended but this story will go on.

* * *

Even though we left Cherbourg in the late 1960s and my children were all very young, we maintained a strong relationship and connection with the place returning regularly to attend funerals, social events and re-unite with family.

My children have taken this connection and developed it further into their lives through the jobs they now undertake. My youngest son, Manny Hegarty, is Manager, Wide Bay Burnett Region Youth Justice Services, based at Hervey Bay and servicing Cherbourg. Mayleah Bemrose, is the Indigenous Employment Officer with the Department of Education, Science and Training, at the Gympie

Regional Office, servicing Cherbourg. My youngest daughter, Moira Bligh, is the Principal Policy Officer, Indigenous Issues, Department of Tourism, Racing and Fair Trading, where she will advise and support Department programs and initiatives operating in places like Cherbourg.

This commitment from my children to Cherbourg comes from their deep desire to still be involved in their community as well as to show that Cherbourg people can aspire to be whatever they want to be.